The Art of Garden Photography

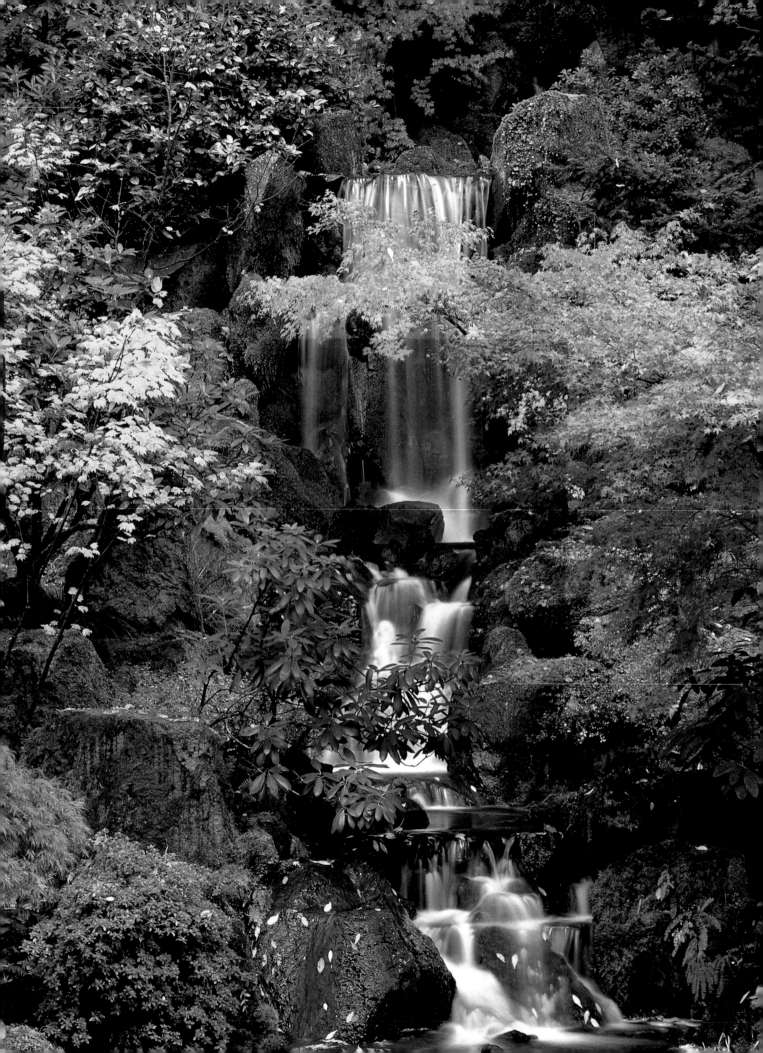

The Art of GARDEN PHOTOGRAPHY

IAN ADAMS

TIMBER PRESS
Portland ~ Cambridge

Published in 2005 by

Timber Press, Inc.
The Haseltine Building
133 S.W. Second Avenue, Suite 450
Portland, Oregon 97204-3527, U.S.A.

Timber Press
2 Station Road
Swavesey
Cambridge CB4 5QJ, U.K.

www.timberpress.com

Printed in Singapore

Library of Congress Cataloging-in-Publication Data

Adams, Ian.
 The art of garden photography / Ian Adams.
 p. cm.
 Includes bibliographical references and index.
 ISBN 0-88192-680-9 (pbk.)
 1. Photography of gardens. I. Title.
 TR662.A33 2005
 778.9'3--dc22
 2004012685

A catalog record for this book is also available from the British Library.

CONTENTS

PREFACE

During the 1990s I began conducting garden photography workshops and seminars, and many of the participants in these programs asked me to recommend a book on the subject. After searching the Internet and making several visits to local booksellers, I learned, much to my surprise, that although there were numerous texts on nature photography, notably John Shaw's excellent books published by Amphoto, virtually nothing comprehensive was available on garden photography, with the single exception of *Photographing Plants and Gardens* by the fine English photographer Clive Nichols, published in 1994. But while Nichols's book provides a good introduction to the basic tools and techniques of garden photography, it does not cover some very important topics, including digital photography. And digital cameras now outsell film cameras by about ten to one.

When I set out to write my own garden photography book, I resolved to address not only digital photography but also key issues such as how to scout and prepare a garden for a photographic session, how to photograph people and animals in the garden, how to photograph indoor flower shows and gardens at night, how to find fine North American gardens to photograph, and how to make color prints from garden photographs. I also decided to include information about organizations, books, magazines, and Web sites that may be useful to garden photographers. The end result is, I hope, the garden photography book I was always looking for but could never find.

Excellent garden photographs can be taken with film, and this book does cover film-based garden photography. The advantages of 35 mm digital photography are extremely compelling, however, and I strongly recommend it, with a few caveats, to participants in my workshops and seminars. I have provided an overview of the selection and use of digital cameras and other digital tools, but it should be noted that digital photography is a complex, rapidly evolving technology, and a detailed, in-depth treatment is well beyond the scope of this book. Books on Photoshop, for example, often include more than five hundred pages—and there are many of them! My bookshelf is stocked with the best of these weighty digital guides (I confess I'm addicted), and my favorites are referenced in this book.

Gardening remains among the most popular pastimes. I hope this book will help you to better document and interpret the visual fruits of your gardening efforts and visits for posterity. Good luck with your garden photography!

ACKNOWLEDGMENTS

First and foremost I would like to thank Neal Maillet, executive director at Timber Press, for his patience and willingness to allow me the time needed to bring my information on digital photography as up to date as possible.

Much of the material included in this book was developed from notes and handouts prepared for the garden photography workshops and seminars that I have conducted for the Cleveland Botanical Garden, Garden Writers Association, Holden Arboretum, Longwood Gardens, Maine Photographic Workshops, Perennial Plant Association, Phipps Conservatory, and Stan Hywet Hall and Gardens. I would like to thank the staffs of these fine organizations for their sponsorship, generosity, and support, and the many participants in the workshops and seminars for their encouragement and useful feedback.

Special thanks to fellow photographers Alan and Linda Dietrich, Barry Haynes, Adam Jones, Jennie Jones, William Manning, Gary Meszaros, Bill Rich, Jim Roetzel, and Rick Zaidan, who provided inspiration, offered technical tips and suggestions, and exchanged many ideas and experiences over a good meal or glass of wine.

I am also indebted to the many garden owners and designers who allowed me to photograph their gardens, including Afton Villa Gardens, Pat Armstrong, Asticou Azalea Garden, Bellingrath Gardens, Craig Bergmann, Libby Bruch, Chicago Botanic Garden, Tracy DiSabato-Aust, Charles Freeman, Mimi Gayle, Bob and Jacqueline Gill, Jim Hagstrom, Kingwood Center, Linda Klein, Elsie Kline, Magnolia Plantation, Joyce Marting, Middleton Place, Cliff Miller, Vicky Nowicki, the Pattie Group, Bobbie Schwartz, Sabrena Schweyer and Samuel Salsbury, Leslie Scott, Valerie Strong and George Faddoul, Don Vanderbrook and Tony Badalamente, Diane and Kent Whealy, Wheeler Landscaping, Winterthur, and Zemurray Gardens.

Finally, as always, thanks to my parents, Margie and Tony McCarthy, and to Neil, Sandi, Kelly, and Stacy for their continuing support and encouragement.

EQUIPMENT

Most of the questions I receive from participants at my garden photography workshops and via e-mail have to do with equipment, especially cameras, lenses, film, scanners, and inkjet printers. Virtually no one asks about photographic subjects, which in my opinion are much more important and intriguing. I like to point out that it is the photographer who really makes the photograph: the finest cameras and lenses are no substitution for hard work, a clear vision, great light, and a strong picture composition.

"Of course," reply my students. "But what camera and lenses *do* you use?" With this question in mind, and in the interest of reducing the number of e-mails I receive each day, I have compiled a list of the equipment I use in my own garden photography:

Two Fuji GX680 6 × 8 cm view cameras (film only) with 65 mm, 100 mm, 135 mm, 180 mm, and 250 mm Fujinon lenses

Two Nikon F100 35 mm film cameras and two Fuji S2 Pro 35 mm digital cameras with the following Nikon lenses:
24–120 mm f/3.5–5.6G AF-S VR IF-ED Zoom-Nikkor (my standard lens)
17–35 mm f/2.8D AF-S IF-ED Zoom-Nikkor (my wide-angle lens)
70–180 mm f/4.5–5.6D ED Zoom Micro-Nikkor (my close-up lens)
200 mm f/4 Micro-Nikkor (another favorite close-up lens)
28 mm f/3.5 PC-Nikkor (for architectural perspective control)
80–400 mm f/4.5–5.6D VR ED Zoom-Nikkor (mostly for wildlife)
500 mm f/4P IF-ED Nikkor (for wildlife)
TC-14A and TC-14B 1.4x Nikon teleconverters (rarely used)
Nikon PK-13 extension tube
Various cable releases

Gitzo G1348 and Manfrotto 3444 carbon fiber tripods with Arca Swiss Monoball and Kirk BH-1 tripod heads

Nikon circular polarizing filters

Pentax digital spot meter and Konica Minolta color or flash meter

Nikon SB-28 and SB-24 flashes and Nikon SB-29 ringlight (for insects)

Photoflex 42-inch diffuser and 12-inch gold or silver reflector

Tamrac Super Pro 14 and Lowepro Elite AW camera bags

By all means invest in the best photographic tools you can afford, but try to avoid the common photographic equipment diseases, including camera craving, lens lust, accessory angst, and—spreading rapidly in this digital age—megapixelitis. Having cautioned you against these complaints, I must admit that I enjoy testing and using new equipment, and I am by no means an equipment minimalist, having invested heavily not only in cameras, lenses, and tripods but also in computer gear and color inkjet printers—alas, with no end in sight, given the rapid rate of improvement and innovation in photography equipment, especially in the digital field.

Whatever your equipment, make sure it is insured against loss or theft. If you are a hobbyist you may be able to add a camera equipment rider to your home insurance policy. Professional photographers will want to invest in a separate policy in which each item of camera equipment is listed together with its replacement value. Be sure to update the list of equipment and replacement values each year before renewing the policy. I carry a copy of this list on all my photography trips.

CAMERA FORMAT

Cameras are available in a wide variety of formats, ranging from the tiny APS (Advanced Photo System) format, which uses film only 24 mm long per frame, to large-format sheet film of 4 × 5 inches or even 8 × 10 inches. For a variety of reasons, most professional garden photographers use 35 mm or medium-format equipment, which uses film from 6 × 4.5 cm to 6 × 9 cm per frame.

APS and Large Format

APS cameras are too small to provide the quality needed for large prints and offer minimal lens coverage, no lens interchangeability, and little user control of exposure or depth of field. Moreover, slide film is not available in APS format. At the other end of the scale, 4 × 5 inch or larger view cameras offer the ultimate in image quality but are not suitable for garden close-ups and are very cumbersome and slow, making them inappropriate for situations in which a large number of photographs of many sections of a garden need to be taken, especially in a limited time period. Sheet film is also very expensive, $4–$5 per photograph, and the superb quality is simply overkill for most book and magazine requirements. I don't know any professional garden pho-

tographers who use a 4 × 5 inch view camera as their primary tool. I owned and used a Sinar 4 × 5 inch view camera for many years and produced hundreds of razor-sharp, exquisitely detailed landscape images with it, but I sold the entire system to help finance my transition into digital photography, with no regrets so far.

Medium Format

Medium format offers an excellent compromise between the speed and flexibility of 35 mm and the improved picture quality of a large-format 4 × 5 inch view camera.

At the smaller end of this format, a number of camera manufacturers, including Contax, Fuji, Mamiya, and Pentax, offer 6 × 4.5 cm cameras, which offer most of the speed and flexibility of 35 mm plus a 300 percent increase in film area. Hasselblad produces a superbly engineered 6 × 6 cm camera, and Bronica, Mamiya, and Pentax offer 6 × 7 cm cameras. I've never liked square formats like 6 × 6 cm, preferring a more rectangular picture space, and in 1992 I purchased Fuji's unique GX680 camera, which provides a large 6 × 8 cm format with an aspect ratio very similar to the popular 8 × 10, 11 × 14, and 16 × 20 print sizes. In addition, the Fuji GX680 offers a rotating, interchangeable back and a complete range of tilt, swing, and shift movements on the front lens standard, allowing superb control of depth of field and perspective. Many of the scenic garden photographs included in this book were taken with the GX680. Despite having switched from 35 mm film to 35 mm digital, I continue to use the GX680 for the tremendous image control and large image area on film, which allows me to produce 30 × 40 inch and 40 × 50 inch Epson UltraChrome inkjet prints on my Epson Stylus Pro 9600 with ease. The only major disadvantage to this camera is its sheer bulk, which makes lugging it around in a large garden a warping chore—definitely not for the fainthearted. Fuji makes a digital back for the GX680, but at a list price of $29,000 it is well beyond my current budget!

35 mm Format

The majority of garden photographers use 35 mm for all, or at least most, of their garden photography. This format is available in a compact (often called point-and-shoot) camera or an SLR (single-lens reflex) camera. Both can be used effectively, though SLRs offer much more flexibility and many more features.

Point-and-shoot 35 mm cameras are offered by most major SLR manufacturers. They are very lightweight and have a built-in zoom lens (usually around 38–105 mm), a built-in flash, autofocus, and a variety of programmable shooting modes and exposure metering modes. Either color slide or print film may be used. Point-and-shoot cameras have three major limitations, however: a lack of lens interchangeability, a viewfinder that makes it difficult to see the precise framing of the picture area, and an inability to connect to remote flash units. For these reasons most garden photographers prefer 35 mm SLR cameras.

I have used Nikon 35 mm SLR cameras with great satisfaction for more than twenty years, but excellent garden photographs may be taken with any reputable brand, including Canon, Contax, Konica Minolta, Leica, Olympus,

Pentax, and others. Canon and Nikon are the most popular brands used by professional photographers and offer the largest systems of cameras, lenses, and accessories.

The following SLR camera features are highly desirable for garden photography, regardless of brand name:

A broad range of interchangeable lenses, ranging from very wide-angle (20 mm or less) through long telephoto (300 mm or more) and including specialized lenses for close-up photography and perspective or sharpness control

Autofocus, with the ability to switch to manual focus

A choice of TTL (through-the-lens), multisegment, and spot exposure metering systems, with an exposure compensation system that facilitates bracketing exposures

A full range of shutter speeds and apertures (f-stops) and the ability to use the camera in aperture-preferred, shutter-speed-preferred, or fully manual modes—for garden photography, in which depth of field is critical, I recommend you use the aperture-preferred mode on your camera

A depth-of-field preview button or control

The ability to connect to a range of remote flash units

The ability to use a cable release to minimize camera vibration at slow shutter speeds

Many 35 mm SLR cameras offer facilities such as autobracketing, autofocus tracking systems, programmed exposures, eye-controlled viewfinders, and other marvels of electronic automation. While some of these features are nice to have when photographing wildlife or other fast-moving subjects, they are not important for garden photography.

Each 35 mm SLR camera manufacturer offers a range of cameras with all the most important features, priced from a few hundred dollars to more than a thousand for the basic camera body. The most expensive professional-level camera bodies, such as the Nikon F100 and F5 and the Canon EOS series, are engineered from more rugged materials like titanium alloy and offer better protection against dust and moisture as well as shutters that are built to take the type of day-to-day punishment that can be inflicted by a hardworking professional photographer. By all means buy the best camera bodies you can afford, but it is certainly not necessary to own a top-of-the-line 35 mm SLR camera to take great garden photographs. A better investment would be to buy two identical or similar medium-priced camera bodies so that one can be used as a backup in the field. Even the best cameras occasionally malfunction: having a backup available on a garden photography assignment or field trip can spell the difference between success and disaster.

LENSES

More than any other piece of photography equipment, with the exception of the film or digital sensor, the lens you use will determine the sharpness, color fidelity, and contrast of your garden photographs. You can take beautiful photographs with medium-priced or even inexpensive camera bodies, but you should invest in the finest lenses you can afford.

In the early and even mid 1990s very few high-quality 35 mm zoom lenses were available, but the years since then have seen the advent of improved material control and computer-aided design and production, and I can unhesitatingly recommend that you purchase several zoom lenses for the vast majority of your garden photography. In general I recommend sticking to lenses made by the manufacturer of the camera bodies you use (Canon, Nikon, and so forth), although some excellent-quality lenses designed to fit most popular 35 mm camera brands are also available from companies such as Sigma, Tamron, and Vivitar.

Zoom lenses are available in one-ring and two-ring versions. With one-ring zooms, a single movable barrel is used to focus (by twisting the barrel) and zoom (by sliding the barrel in and out). With two-ring zooms, one ring is used to focus and a second concentric ring is used to operate the zoom feature. I strongly recommend purchasing only two-ring zooms. These are much more controllable and precise, wear much better, and do not creep out of adjustment when pointed down at the ground, which happens a lot in garden photography.

In recent years more than 75 percent of my garden photography work using 35 mm film has been accomplished with a single lens, the Nikon 24–120 mm f/3.5–5.6G AF-S VR IF-ED Zoom-Nikkor. When I switched to 35 mm digital photography I added a Nikon 17–35 mm f/2.8D AF-S IF-ED Zoom-Nikkor to provide wider-angle lens coverage for my Fuji S2 Pro digital cameras, in which the digital sensor is only about two-thirds the size of a piece of 35 mm film. For close-up work and longer-focus photography I use the razor-sharp 70–180 mm f/4.5–5.6D ED Zoom Micro-Nikkor and occasionally an older 200 mm f/4 Micro-Nikkor when I need a slightly longer working distance for skittish butterflies and other insects. For longer-focus work and some wildlife subjects, I use the 80–400 mm f/4.5–5.6D VR ED Zoom-Nikkor, which includes vibration reduction technology to facilitate photography at slower shutter speeds.

The highest-quality lenses are made from combinations of special optical glass, such as Nikon's extra-low dispersion (ED) lenses and Canon's L-series lenses. These superb lenses are truly optical works of art.

Autofocus Versus Manual Focus

Virtually all modern lenses are designed to couple with the camera body to provide an autofocus capability. All my zoom lenses are autofocus, but I often prefer to switch off the autofocus and focus the lens manually. This is because I frequently prefer to focus at a specific distance, known as the hyperfocal dis-

tance, in order to maximize depth of field in scenic photographs (see Chapter 4 for more information on both hyperfocal distance and depth of field). Autofocus systems don't understand hyperfocal-distance focusing and are designed to focus on the subject covered by the autofocus sensor engraved in the viewfinder screen. This often requires autofocusing on a specific subject, holding the focus using a special camera button, and recomposing the scene through the viewfinder before taking the picture—an awkward process at best. Although autofocus is a wonderful aid for action and some wildlife photography, it doesn't help much in landscape and garden photography and is by no means a necessary camera or lens feature.

Teleconverters

Teleconverters are optical magnifying glasses that are used in conjunction with a prime camera lens to increase the size of the image, thereby effectively increasing the focal length of the prime lens attached to the teleconverter. In use, the teleconverter is attached to the camera body, and the lens is attached to the other end of the teleconverter. A 1.4x teleconverter increases the prime lens image size by 40 percent and loses 1 stop of light. A 2x teleconverter doubles the prime lens image size but costs you 2 stops of light.

The quality of a teleconverter image is largely a function of the quality of the prime lens it is used with. A Canon teleconverter used with a Canon L-series lens produces a larger image with virtually no measurable loss of quality. Nikon makes three 1.4x and four 2x teleconverters, and it's important to select the right model for the lenses you plan to use with it.

Teleconverters are used a great deal by wildlife photographers to increase the power of long lenses such as 400 mm and 600 mm super telephotos. They are of limited use in garden photography, but by all means carry them if you own them.

TRIPODS, TRIPOD HEADS, AND CABLE RELEASES

A tripod is an essential tool for garden photography. To quote American Express, "Don't leave home without it." Virtually every photograph in this book, with the exception of a couple of handheld photographs of insect close-ups, was taken with the camera firmly mounted on a solid tripod. Using a tripod is key to producing razor-sharp garden photographs with great depth of field. In addition, placing the camera on a tripod allows you to study—really *study*—the composition through the viewfinder, unencumbered by the need to concentrate on holding the camera steady at the same time.

As discussed in Chapter 4, razor-sharp photographs that can be made into large prints require the use of slow shutter speeds, small f-stops, and slow, fine-grained film. You simply cannot hold a camera steady while using slow shutter speeds of ¼ second, ½ second, or longer, which are often required on cloudy days or early mornings and late afternoons of sunny days. Most photographers agree that the slowest shutter speed that can be used effectively with a handheld camera is the reciprocal of the focal length of the lens in use, expressed in seconds. For example, the slowest shutter speed most people can

use with a 50 mm lens is about $\frac{1}{60}$ second, and a handheld 200 mm lens requires a shutter speed of $\frac{1}{250}$ second or faster.

How big a tripod do you need? One well-known professional nature photographer suggests, tongue in cheek, that "you need a tripod as big as a Buick." Another advises, more practically, to "use the biggest tripod your spouse can carry." Although you don't need a monster studio tripod of 10–15 pounds, a sturdy tripod suitable for garden photography will weigh at least 4 pounds, and more likely 5–8 pounds.

Most professional garden and nature photographers use Gitzo or Manfrotto tripods, manufactured by Bogen Imaging. Gitzo tripods are generally acknowledged to be the best, although they are expensive and quite heavy. Most tripod legs are made out of circular or sectional aluminum or carbon fiber, in three or four sections. Carbon fiber is lighter and a delight to use, especially in winter, when metal tripod legs get very cold and hard to touch. Unfortunately, carbon fiber tripods are very expensive—more than $500 for the larger versions. My everyday tripod, the Gitzo G1348, cost $600 (gulp!) without a tripod head, but I wouldn't be without it. Manfrotto, which owns Gitzo, also makes a line of less expensive aluminum tripods, of which the 3021 (silver) and 3221 (black) models are an excellent, sturdy, affordable choice, although they are a little short for tall photographers. I also own a Manfrotto 3444 carbon fiber tripod, which is very light but works well for my garden photography as long as there is little wind and I'm not using very long lenses.

Make sure you select a tripod that allows you to position the camera at head height, without the need to extend the centerpost of the tripod. Extending the centerpost more than an inch or so essentially converts a tripod into a less stable monopod. Don't do it! Instead, pick a tripod with leg sections that extend to at least your full height. Preferably they should extend even higher so that you can use the tripod on a hillside, where in order to compose a picture standing upright looking down the hill you'll need to extend at least one leg of the tripod to a height taller than yourself. My favorite Gitzo tripods, the G340 and G1348, don't have centerposts at all. Nor are the legs connected in any way: each leg can be moved independently to precisely position the tripod on uneven ground.

Another benefit to choosing a tripod without a centerpost, or with a short centerpost, is the ability to spread the tripod legs out so that the tripod can be positioned close to the ground for close-up photographs of flowers, mushrooms, ground covers, and other low-lying subjects. The Gitzo G340 and G1348 tripods allow me to spread the legs absolutely flat on the ground.

Don't believe the ridiculous tripod advertisements that suggest you reverse the centerpost and hang the camera upside down when taking close-ups. Not only will all the camera controls be out of reach and awkwardly placed, but when you position yourself in the space between two of the tripod legs in order to reach the camera, the camera will also be pointing straight at the third tripod leg. It simply can't be done, especially with long lenses. Clearly the folks who design these ads never have to use the products they promote!

When using a tripod, point one leg toward the subject so that you can work in the space between the other two legs. With Gitzo tripods, which have circular locking collars, hold on to the top section of the tripod leg, nearest

2

FILM AND FILTERS

Both Canon and Nikon now generate as much as 80 percent of their sales volume and sales revenue from digital cameras and other digital products, and film giant Kodak is concentrating its efforts on developing digital products as demand for its "traditional" products, including film, continues to decline. Although sales of film cameras and film continue to lose ground as the digital juggernaut moves inexorably forward, it is equally true that you can take great photographs of gardens using film. Professional garden and nature photographers, including yours truly, have made a good living for decades using film. Film is certainly not dead, and as a serious garden photographer you should have a basic understanding of film and film-related products, including filters, even if you plan to use digital cameras for most of your work.

COLOR FILMS

Although you can photograph gardens using black-and-white film and other specialized films, such as infrared, most of us choose to view, document, and interpret gardens in color, using either color transparency (positive) film or color print (negative) film. I strongly recommend using color transparency film for your garden photography.

Color transparency film is a WYSIWYG (what-you-see-is-what-you-get) product that is easy to evaluate, using a loupe and a light table, with respect to sharpness, exposure, color, composition, and other attributes. Color print film, on the other hand, is pinkish orange and very hard to evaluate. Color transparency film also allows you total control of the photographic process, whereas a color print is made by an automated machine in a color lab, over which you have no control. These machines are designed to compensate for

9. Dogwood and pond, Spring Grove Cemetery, Cincinnati, April. Nikon F3, 28 mm Nikkor, Gitzo 320 Studex tripod, polarizing filter. The polarizing filter lowered the tone of the water by reducing the reflection from the pond's surface, allowing the overhanging leaves of the dogwood to stand out against the background of the pond. It also intensified the colors in the scene.

29

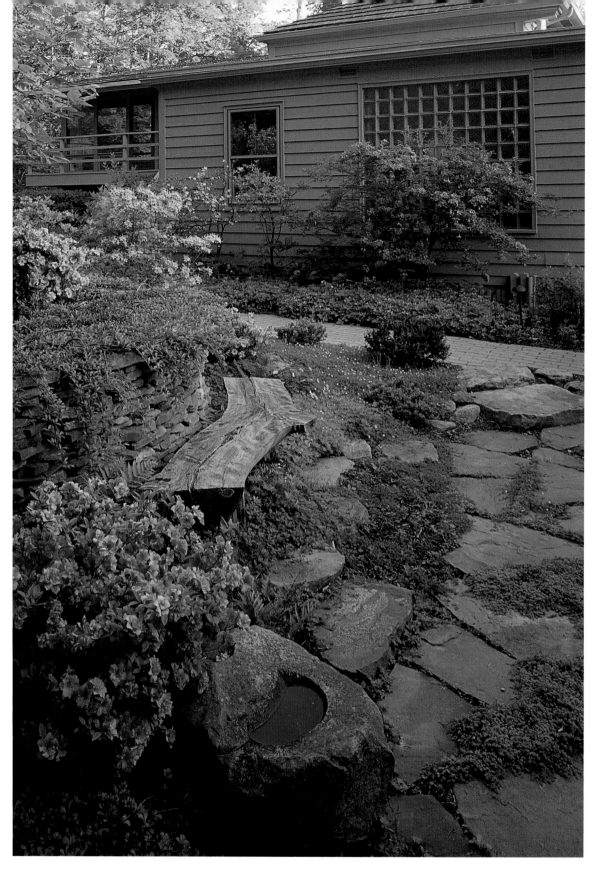

10. Courtyard, Moreland Hills, Ohio, June. Nikon F100, 24–120 mm Zoom-Nikkor, Fujichrome Velvia, Gitzo 340G tripod. This photograph was taken at sunrise, when the reflected light from a blue sky imparted a cool, slightly bluish color cast to the scene. No filter was used.

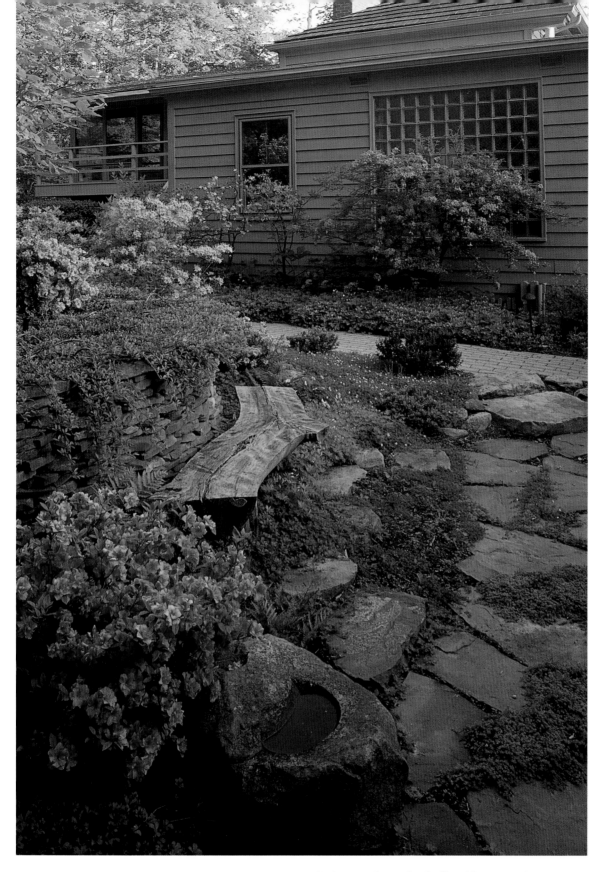

11. Courtyard, Moreland Hills, Ohio, June. Nikon F100, 24–120 mm Zoom-Nikkor, Fujichrome Velvia, Gitzo 340G tripod, 81B filter. In this variation, an 81B filter was used to warm the colors slightly. Note especially the effect on the paving stones.

Graduated Neutral-Density Filters

Another filter popular among nature and landscape photographers is the graduated neutral-density filter. These filters are usually rectangular and designed to slide into a special holder that is attached by clips to the front of the camera lens. The top section of the filter is neutral gray, and the bottom is clear glass or resin. The purpose of this filter is to equalize the tones between the brighter sky and the much darker land in highly contrasty lighting situations. The graduation between clear glass or resin and the gray part of the filter is usually feathered to provide a gradual transition.

I've never been especially fond of graduated neutral-density filters, for several reasons. First, if the contrast between the sky and the land is very high I'm not sure I would want to bother taking the photograph in the first place. Second, the filters are rather time-consuming to attach to the lens, and it's difficult to position the edge of the gray section precisely. Third, horizons are rarely flat, so part of the land is usually covered by the filter, making it appear artificially dark. I have even seen photographs in which the reflection of clouds on a lake is lighter than the clouds themselves, something that never occurs in nature. Although I own a set of excellent 100 mm HiTech graduated neutral-density filters and a matching filter holder, I rarely use them, and never in a garden situation. Photographs 12, 13, and 14 were taken in the mountains, the only environment in which I've ever used the "grads." On the other hand, many other professional landscape photographers, including the late Galen Rowell, swear by these filters and would never be without them. Perhaps if I photographed more mountaintop gardens?

If you do decide to invest in a set of these filters, here's a tip for lining up the edge of the gray section of the filter with the horizon. Fold a piece of paper over the filter so that the top of the paper is positioned at the edge of the graduation. Now, holding the paper in place, slide the filter into the holder, and look through the camera. The opaque paper allows you to precisely judge where the graduated section of the filter ends so that you can easily position it. Simply remove the paper, and voilà! The filter is aligned exactly.

12. Clingman's Dome, Great Smoky Mountains National Park, North Carolina, April. Nikon 8008s, 24–120 mm Zoom-Nikkor, Fujichrome Velvia, Gitzo 340G tripod. A late snow had covered the tops of the mountains when I took this photograph. The film was unable to record the strong contrast between the foreground trees and the distant, hazy mountains. No filter was used.

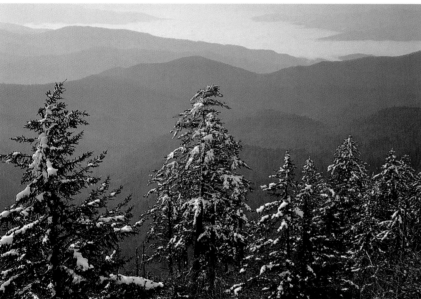

13. Clingman's Dome, Great Smoky Mountains National Park, North Carolina, April. Nikon 8008s, 24–120 mm Zoom-Nikkor, Fujichrome Velvia, Gitzo 340G tripod, 2 f-stop graduated HiTech neutral-density filter. A 2 f-stop graduated neutral-density filter was positioned to cover the top section of the photograph. Note the lowering in tone of the distant hills, as well as of the tops of the foreground trees.

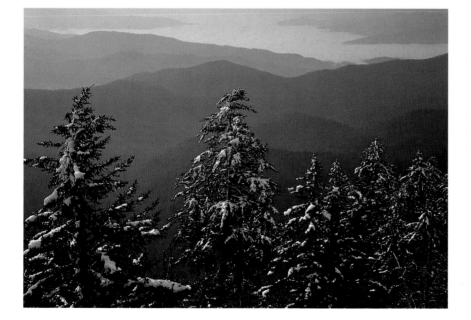

14. Clingman's Dome, Great Smoky Mountains National Park, North Carolina, April. Nikon 8008s, 24–120 mm Zoom-Nikkor, Fujichrome Velvia, Gitzo 340G tripod, 2 f-stop and 3 f-stop graduated HiTech neutral-density filters. In this version I used a 2 f-stop and a 3 f-stop graduated neutral-density filter in combination to dramatically darken the top section of the photograph.

3

DIGITAL CAMERAS

The photography world is increasingly digital, with dramatic improvements in the quality and affordability of digital cameras, scanners, and other equipment. As this technology continues to improve at a rapid rate, it is clear that digital photography will play a major role in the future. For this reason, many professional photographers have switched from film to digital.

HOW DIGITAL CAMERAS WORK

Digital cameras don't use film. Instead, the image is captured as a rectangular array of colored dots, called pixels, on a special sensor called a charge-coupled device (CCD), then stored as a digital file on a compact flash card. Using an inexpensive flash card reader, you can upload your digital photographs to a personal computer, process them with an image editor such as Photoshop, and use them on a Web site, as an e-mail attachment, in a document, or for making color prints on a desktop inkjet printer.

Several major camera manufacturers, notably Canon, Fuji, and Nikon, offer 35 mm digital SLR cameras designed to work with the lenses they make for film cameras. Examples include the Canon EOS-10D and EOS-1Ds, Fuji S2 Pro, and Nikon D1x and D100. However, even the least expensive of these cameras costs around $1000, and newer models such as the Canon EOS-1Ds and Kodak SLR-n are $5000–$7000. Fortunately, several manufacturers offer much less expensive, consumer-oriented digital cameras such as the Canon PowerShot, Fuji FinePix, Konica Minolta DiMAGE, and Nikon Coolpix models. These less expensive digital cameras are capable of producing excellent-quality garden photographs and are very effective for photographing butterflies, dragonflies, and other photogenic insects that may visit your garden.

Look for the following essential features when shopping for a digital point-and-shoot camera for garden photography:

An image size of at least 3 MP (megapixels)

A zoom lens with autofocus, with at least a 4x range (35–135 mm equivalent)

Macrofocusing capability (most digital cameras will focus to within a few inches of the front of the lens)

An optical or electronic viewfinder, plus a coated monitor viewing screen

A tripod socket

You can expect to pay $200–$500 for a digital camera with these features.

A new breed of compact, sophisticated digital cameras has appeared, with an array of features that rival 35 mm SLR digital cameras. These high-end point-and-shoot cameras include the Canon PowerShot Pro1 (8 MP), Konica Minolta DiMAGE A2 (8 MP), Nikon Coolpix 8700 (8 MP), Olympus C-8080 Wide Zoom (8 MP), and Sony Cyber-shot DSC-F828 (8 MP). These powerful digicams have all the features of compact point-and-shoot digital cameras, plus the following:

An image size of 5–8 MP

A manual or motorized zoom lens with a range of 6x or more (typically 28 mm–200 mm), plus the ability to add specialized wide-angle and telephoto accessory lenses

The ability to save digital images as 16-bit RAW files as well as 8-bit JPEG files

A built-in pop-up flash, plus the ability to interface with separate flash units

These digicams provide image quality that is on a par with the more expensive 35 mm SLR digital cameras, for a lower price of $700–$1100. They are certainly capable of producing garden photographs of superb quality, as well as color prints up to 20 × 30 inches, and are an attractive proposition for the garden photographer who wants a very compact, "do everything" camera for less than $1000. I purchased a Konica Minolta DiMAGE A2 in 2004 and have found it to be virtually the equal of my 35 mm Fuji S2 Pro cameras in most garden photography situations.

The only real limitations of a digicam are the inability to change lenses and the lack of a true optical viewfinder. On the other hand, a digicam's sealed lens eliminates the possibility of dust settling on the image sensor, which can be a problem with 35 mm SLR digital cameras.

Make sure you take the time to read and understand the reference manual that comes with your digital camera. Although most digital cameras are easy to use, they offer a bewildering array of options, controls, and features. Be prepared to spend several hours reading the manual and getting to know your camera and how it operates. *How to Do Everything with Your Digital Camera*

(2002) by Dave Johnson is an excellent reference, as are the *Short Course in Nikon Coolpix* books by Dennis Curtin (1999, 2000, 2002a, 2002b).

LENSES FOR 35 MM DIGITAL SLR CAMERAS

Canon and Nikon 35 mm digital cameras are designed to be used with the lenses that work for Canon and Nikon film cameras. Fuji S2 Pro and Kodak SLR-n cameras are based on the Nikon N80 camera body and are designed to be used with Nikon lenses.

Unfortunately, it isn't quite that simple, except for the Canon 1Ds and Kodak SLR-n cameras, which use a CMOS digital sensor that is 24 × 36 mm, the same size as a piece of 35 mm film. With these examples, a 35 mm lens used on a film camera is still a 35 mm lens used on the digital camera. All the other Canon and Nikon digital 35 mm SLRs, however, as well as the Fuji S2 Pro, which I use, have a digital sensor that is roughly a third smaller than a 24 × 36 mm piece of film. This means that a 35 mm wide-angle lens on a film camera becomes roughly a 50 mm normal lens on a digital camera, and a 100 mm lens becomes a 150 mm lens. This is good news for wildlife photographers but bad news for scenic photographers, since their 35 mm wide-angle just turned into a normal lens.

What this means is that for garden vistas you may need to purchase a wider-angle zoom lens, such as the 16–35 mm f/2.8 Canon Zoom or the 17–35 mm f/2.8 Zoom-Nikkor. Both lenses are excellent but are also expensive, at more than $1000 each.

DIGITAL CAMERAS IN THE GARDEN

I recommend that you set the sensitivity, the digital equivalent of film speed (ASA), to "100" or less and the image quality to "fine" or "RAW." Be sure to install a flash card with a capacity of at least 128 MB (megabytes) and preferably 256 MB. To begin with, simply set the camera's exposure mode to "program" and "autofocus." Ignore the built-in viewfinder, and use the camera monitor screen to view and compose the image.

Once you've taken a digital photograph, you can review it immediately on the monitor screen. If the photo looks good, move on to the next subject. If not, simply delete the image from the flash card. This is the single biggest advantage of a digital camera—instant feedback, and no film to process!

When you get home, insert the compact flash card containing your photos into a flash card reader attached to your personal computer via a USB (Universal Serial Bus) or firewire port. Run the software package supplied with your digital camera to view, crop, and adjust each photo and to print your garden images on a color inkjet printer. You can also use an image editor such as Photoshop or Photoshop Elements to perform more extensive editing functions. Digital images taken at the "fine" quality setting on, say, a 3.3 MP digital camera at full size can easily be enlarged to a high-quality 6 × 8 inch, 8 × 10 inch, or even 11 × 14 inch color print.

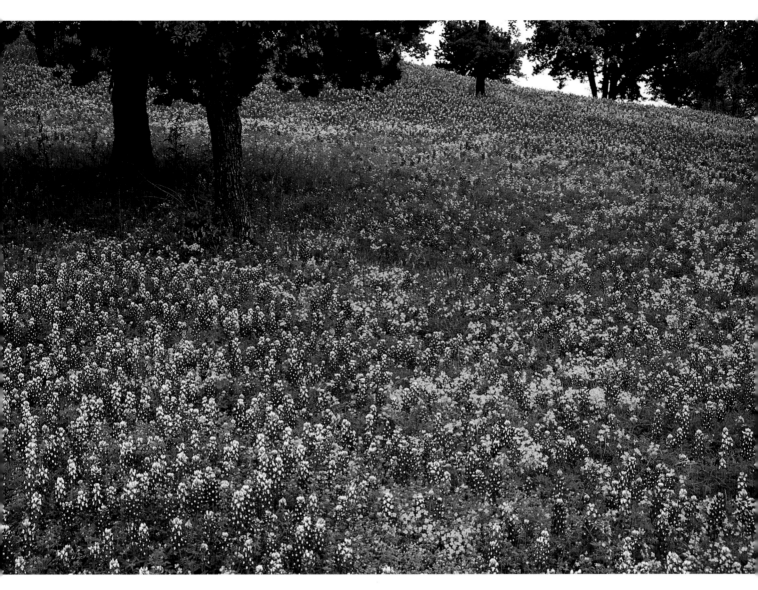

30. Texas Hill Country display, near Marble Falls, April. Nikon 8008s, 28 mm Nikkor, Fujichrome Velvia, Gitzo 340G tripod. One of my favorite destinations in early April is the Texas Hill Country west of Austin, where bluebonnets and dozens of other wildflowers bloom along the roadsides. The soft, overcast light and medium tones that predominate in this scene were easy to expose using the multisegment metering system in my camera. I set the f-stop to f/11 and used the meter's suggested shutter speed, about $1/15$ second, without any adjustment.

white, yellow, and pink flowers that are lighter than middle tone, as well as dark rocks, deep shadows, and other subjects that are darker than middle tone. In addition, contrasty lighting such as bright sunshine creates complex patterns of light, dark, and middle tones that can be very challenging for camera meters. It's important to learn how to recognize these metering situations and know how to deal with them.

Photographs 30 and 31 are examples of straightforward exposure metering situations. Both scenes are full of predominantly middle-toned subjects in

31. Dwarf crested iris, Ramsey Cascade Trail, Great Smoky Mountains National Park, Tennessee, April. Nikon 8008s, 105 mm Micro-Nikkor, Fujichrome Velvia, Gitzo 340G tripod. The middle-toned iris blossoms and green leaves made this scene very easy to meter. I stopped down to f/16 to ensure sharp focus throughout and used the shutter speed indicated by the camera meter without any adjustment. I positioned the camera to fill the entire picture frame with flowers and leaves to create a graphic, abstract pattern.

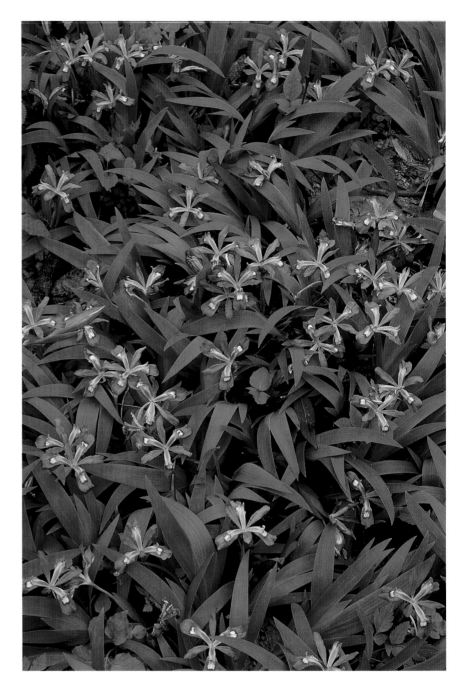

diffuse, overcast light. Multisegment, center-weighted, or spot metering exposure meters should all render the same exposure readings. Just pick the combination of shutter speed and f-stop that provides the required depth of field, and take the photograph. Easy!

On the other hand, the winter scene shown in Photographs 32 and 33 has large areas of highly reflective snow that will confuse many exposure meters and cause them to produce readings that will result in underexposed photographs (as in Photograph 32). With snow scenes and close-ups of light-colored flowers, you must open up and give extra exposure to ensure that these subjects are rendered correctly and not as medium tones.

Modern multisegment camera meters (Nikon prefers the term *matrix metering*, while Canon prefers *evaluative metering*) are marvels of sophistication and generally do an excellent job of metering garden scenes. I nearly always take at least a couple of frames at the exposure indicated by the multisegment meter, which I set as the default metering system on my Nikon F100 and Fuji S2 Pro cameras. Then I bracket my exposures to be on the safe side.

Bracketing is simply taking a few extra exposures above or below the exposure reading indicated by the camera meter. Most cameras allow you to bracket in one-half stop or one-third stop intervals. I prefer to use one-half stop intervals when I bracket. Most cameras provide an exposure compensation setting, usually operated by a thumbwheel, that facilitates bracketing. If you set your camera program to aperture-preferred (A), which I recommend for garden photography, the bracketing will be done by varying the shutter speed electronically, which allows you to preserve the f-stop and therefore the depth of field you need in the scene.

Some photographers feel that bracketing is a crutch and an indication that the photographer doesn't know how to meter a scene correctly. I emphatically disagree. I like to have several exposures of an important scene available, and with digital cameras there is no cost penalty associated with the extra film required for bracketing. The trick with bracketing is to estimate whether the camera meter is likely to overexpose or underexpose the scene, and bracket on just one side of the metered reading. Since there are generally more subjects in gardens that are lighter than medium tone rather than darker than medium tone, I find myself bracketing on the overexposure side most of the time. Remember, light subjects need more light; dark subjects need less light.

Lighting also affects exposure. Both backlit and sidelit subjects require an increase in exposure to render the scene correctly, as with Photographs 34 and 35. With sidelit subjects, open up about 0.5–1 f-stop. With backlit subjects, open up about 1–1.5 f-stops. I virtually always bracket my exposures in these tricky lighting situations to give myself some choices when I examine the photographs on my monitor or light table.

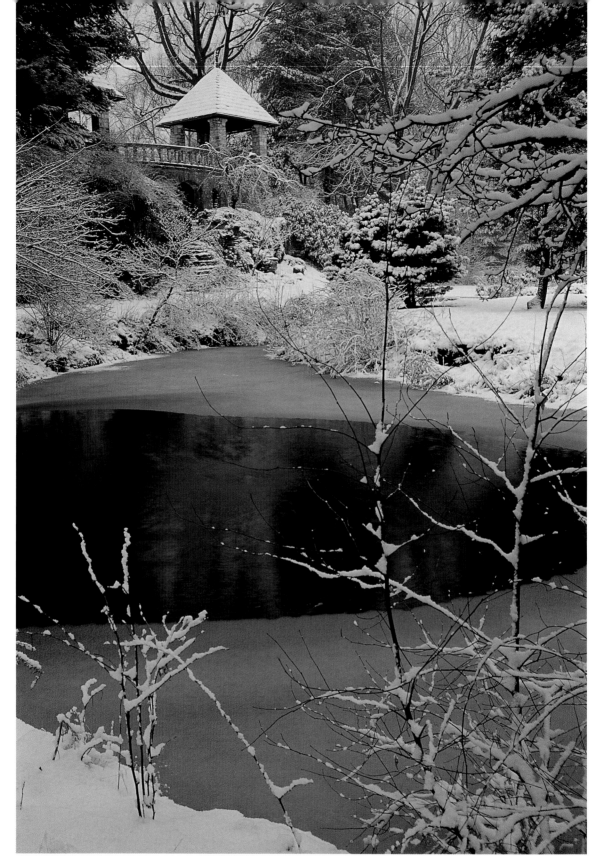

32. Teahouse from the lagoons, Stan Hywet Hall and Gardens, Akron, Ohio, February. Nikon 8008s, 28 mm Nikkor, Fujichrome Velvia, Gitzo 340G tripod. Many of the tones in this winter photograph are lighter than middle gray, and most camera meter readings tend to underexpose snow scenes by up to 2 f-stops or more. To restore the snow to white, adjust the meter's exposure compensation control to give a longer exposure, either using a slower shutter speed, a larger f-stop, or a combination of the two.

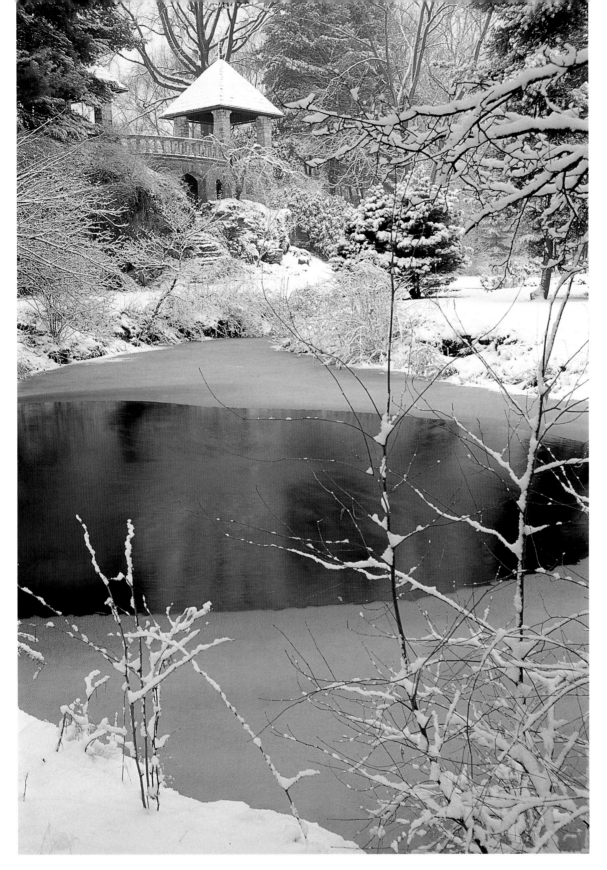

33. Teahouse from the lagoons, Stan Hywet Hall and Gardens, Akron, Ohio, February. Nikon 8008s, 28 mm Nikkor, Fujichrome Velvia, Gitzo 340G tripod. Leaving the f-stop setting at f/16, I adjusted the exposure compensation control to +1, which roughly doubled the effective shutter speed and restored the snow to white. Depending on the amount of white snow and the intensity of the light, 0.5–2.5 f-stops of additional exposure may be needed to correctly expose snow scenes.

34. Tulip trees near Gray's Arch, Red River Gorge, Kentucky, April. Nikon F3, 105 mm Micro-Nikkor, Kodachrome 25, Gitzo 320 Studex tripod. These backlit tulip trees required an exposure increase of about 1 f-stop more than the exposure meter reading, which would have rendered the trees almost a silhouette. Shining through the translucent leaves, this kind of light, also called *contre jour* (against the light), produces a much more exciting effect than frontal light.

The Sunny f/16 Rule

The sunny f/16 rule is a popular metering rule of thumb. It states that for a frontally lit, medium-toned subject in bright sunshine, the correct exposure at an aperture of f/16 is the reciprocal of the ASA of the film, expressed in seconds. For example, the sunny f/16 exposure for Kodachrome 64 is $\frac{1}{60}$ second, and for 100 ASA Fujichrome Provia the sunny f/16 exposure is $\frac{1}{125}$ second (rounded off).

Although this rule works, I virtually never use it, because the bright sunshine it requires is my least favorite lighting for garden photography. In fact, many of my garden photography clients would not accept garden photographs taken in the harsh, glaring light that the sunny f/16 rule requires. Bright sunlight is great for having a barbecue, getting a suntan (or skin cancer!), or resting up while waiting for the "sweet light" of late afternoon. Understand the rule, but avoid the lighting it requires!

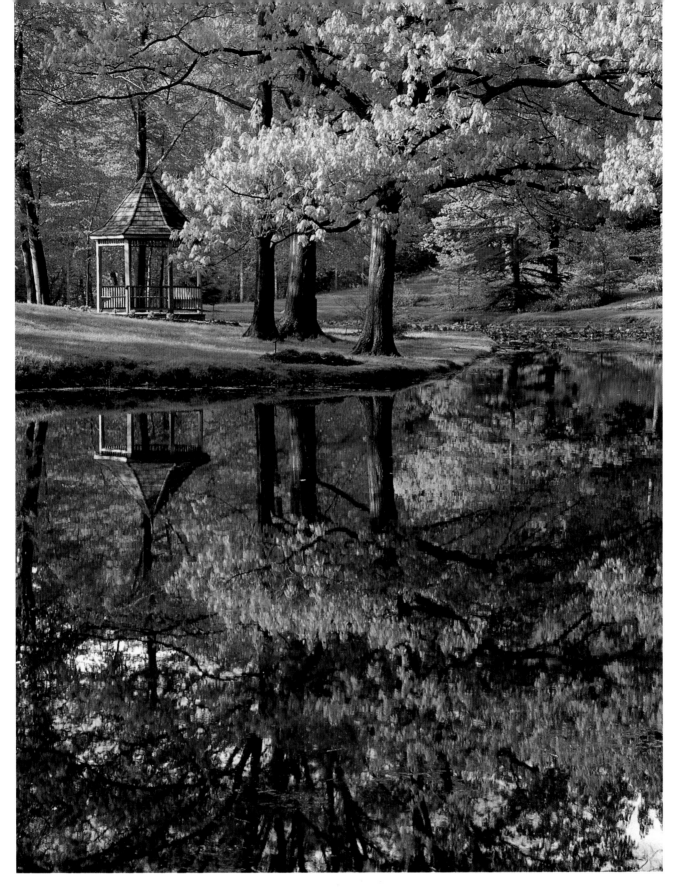

35. Heath pond and gazebo, Holden Arboretum, Lake County, Ohio, May. Nikon F100, 24–120 mm Zoom-Nikkor, Fujichrome Velvia, Gitzo 340G tripod. The sidelight on this spring scene needed an exposure increase of about 0.5 stop. Nearby grows one of America's largest collections of azaleas and rhododendrons.

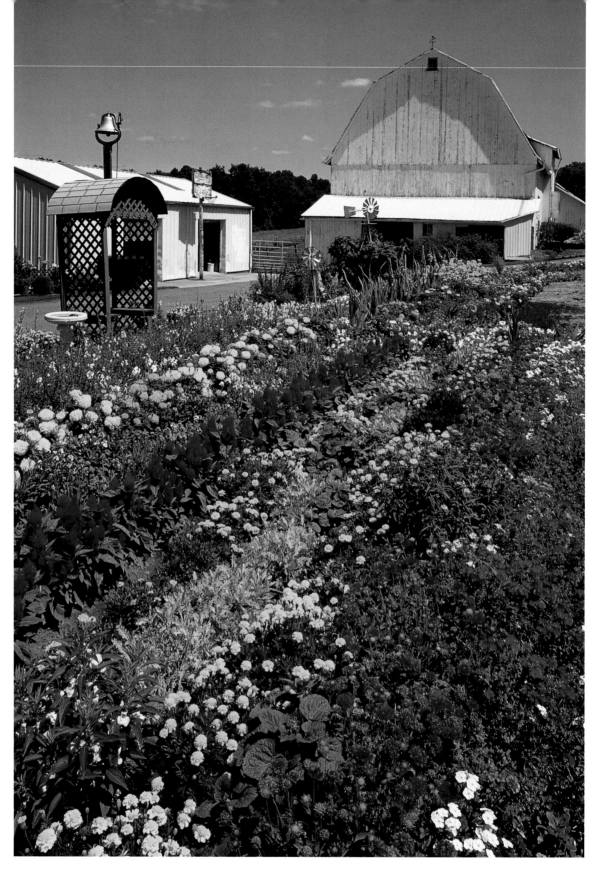

36. Amish farm garden, near Berlin, Holmes County, Ohio, August. Nikon F3, 28 mm Nikkor, Fujichrome Velvia, Gitzo 320 Studex tripod. It was midday under a clear blue sky when I took this frontally lit scene of an Amish garden in the heart of the world's largest Amish community. Using the sunny f/16 rule, the correct exposure for this photograph with 50 ASA Velvia would be f/16 at 1/50 second. I rounded off the exposure to 1/60 second at f/16 to obtain a little more color saturation.

LIGHTING

Excellent lighting is a hallmark of good garden photography. Inappropriate lighting can ruin a well-composed photograph of an attractive garden subject. Conversely, a run-of-the-mill image can be elevated to a fine garden photograph through the use of exquisite lighting. In this chapter we'll examine several types of lighting and compare and contrast their use in garden photography.

LIGHT SOURCES

The primary light source for garden photographs taken outdoors is ambient light from a clear blue, cloudy, or partly cloudy sky. Light from a sunny sky is direct, causing shadows to appear on the side of subjects opposite the sunlight. Early and late in the day, when the sun is close to the horizon, shadows are long. At midday, when the sun is high in the sky, shadows are short. Light from a cloudy sky is diffuse, and shadows are largely eliminated. Mist and fog also cause light to be diffused and can provide a wonderfully ethereal atmosphere for garden photography.

LIGHTING COMPARISONS

Photographs 37 and 38, 39 and 40, and 41 and 42 are examples of the same scene photographed under the direct light of full sun and the diffuse light of an overcast sky just after a shower of rain. Notice that in each case the photograph taken under overcast light shows far more detail and much more saturated color. On the other hand, the blue sky in the sunlit versions is much more attractive than the flat white sky in the cloudy versions. From a garden

37. **Ed and Donna Lambert's garden, Athens, Georgia. Nikon 8008s, 24–120 mm Zoom-Nikkor, Fujichrome Velvia, Gitzo 320 Studex tripod, polarizing filter.** This photograph was taken on a sunny afternoon. I used a polarizing filter to deepen the sky and reduce the strong contrast. Even so, the shadows are blocked up because the color transparency film was unable to handle the tonal range of 7–8 f-stops.

38. **Ed and Donna Lambert's garden, Athens, Georgia. Nikon 8008s, 24–120 mm Zoom-Nikkor, Fujichrome Velvia, Gitzo 320 Studex tripod.** This photograph was taken the next morning, after a rain shower, from virtually the same viewpoint. Notice how the overcast light has reduced the tonal scale to around 5 f-stops, allowing the slide film to record much more detail in the steps and woodland areas. The lack of glare has also produced more neutral colors.

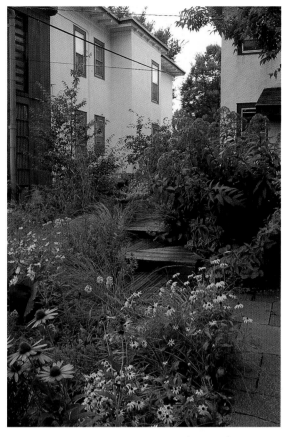

39. Fred Rozumalski's garden, Minneapolis. Nikon 8008s, 24–120 mm Zoom-Nikkor, Fujichrome Velvia, Gitzo 320 Studex tripod, polarizing filter. Another sunny photograph. A polarizing filter intensified the attractive blue sky and lowered the contrast a little, but the slide film was unable to record much shadow detail in the native prairie flowers in the foreground.

40. Fred Rozumalski's garden, Minneapolis. Nikon 8008s, 24–120 mm Zoom-Nikkor, Fujichrome Velvia, Gitzo 320 Studex tripod. The overcast sky is less attractive than the blue sky in Photograph 39, but there is much more detail in the prairie flowers, making this photograph more useful from a documentary viewpoint.

design viewpoint, Photographs 38, 40, and 42 are more informative and easier to print because of the reduced contrast and open shadow areas. Photograph 38 and a variant of 40 were used in Susan McClure's *The Free-Spirited Garden: Gorgeous Gardens That Flourish Naturally* (1999). Some garden book or magazine publishers request that photographers only submit photographs taken under diffuse light.

Technically, using the digital power of Photoshop, it's relatively easy to change the flat white sky in Photographs 38, 40, and 42 to a more attractive blue, using the following process applied to a digital scan made from the color transparency:

1. Make a rough selection of the sky area using the Lasso selection tool of your choice.

2. Use the Magic Wand tool to select the pixels of the flat white sky. You may have to adjust the Tolerance setting to make sure that pixels that are slightly off-white are also selected. To smooth the edges of the selection, make sure that the Anti-aliased box is checked. Make sure that the Contiguous box is unchecked. Feather the selection a few pixels.

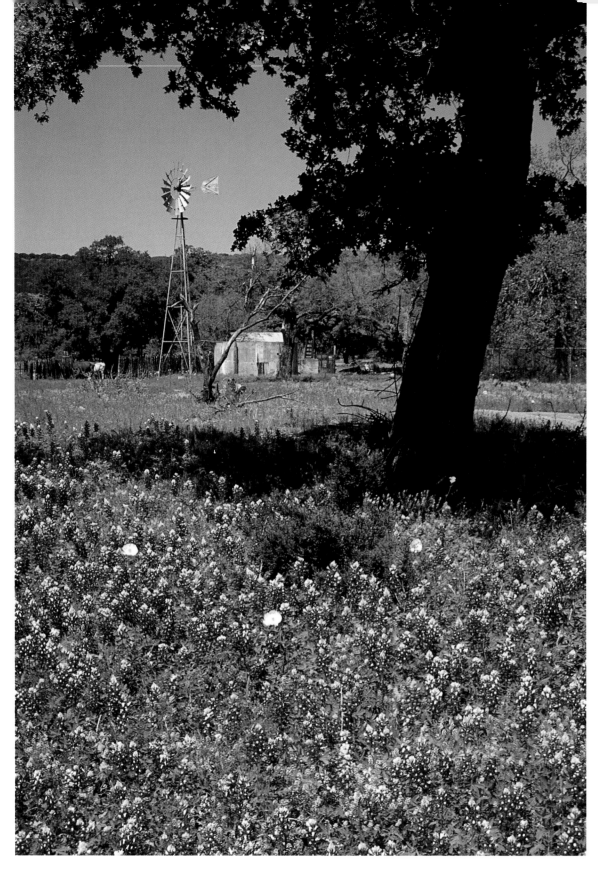

**41. Bluebonnets and old windmill, near Llano, Texas.
Nikon 8008s, 24–120 mm Zoom-Nikkor, Fujichrome
Velvia, Gitzo 320 Studex tripod.** Bright sunny lighting
works well in this open situation, though the shaded
tree trunk is rendered as a silhouette.

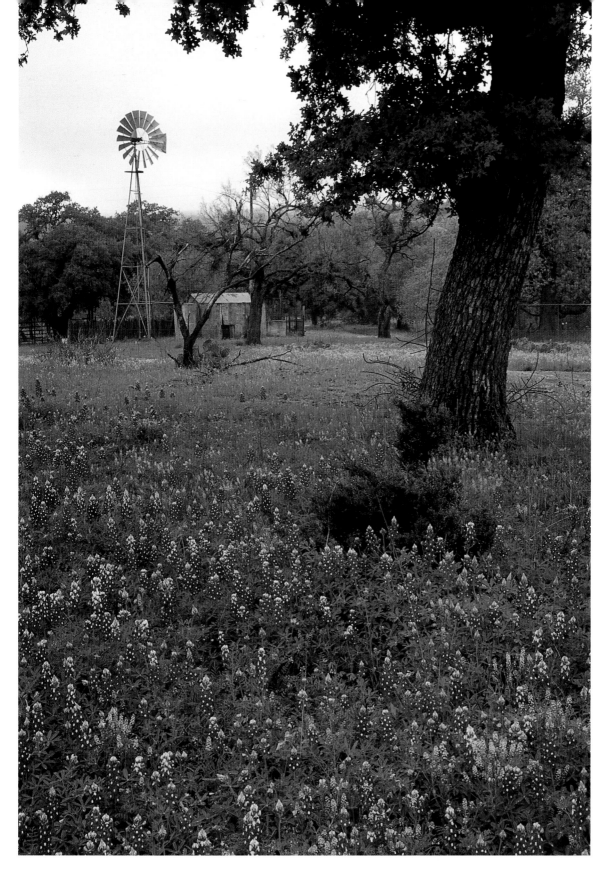

42. **Bluebonnets and old windmill, near Llano, Texas. Nikon 8008s, 24–120 mm Zoom-Nikkor, Fujichrome Velvia, Gitzo 320 Studex tripod.** There is less glare and much more detail in the tree trunk than in Photograph 41, but the sky is rather drab.

3. From the Adjust option on the Image menu, select *Hue/Saturation*. Using the Hue slider, change the white pixels you selected in steps 1 and 2 to a more attractive shade of blue. Adjust the Saturation and Lightness as needed to darken and intensify the blue sky. Use the Zoom tools to examine the sky at 100 percent to ensure that there is a smooth transition between the tree branches and foliage and the sky areas.

Although I would be comfortable making this change to produce an interpretive color print of the garden scene, I would have strong ethical concerns about submitting the digitally manipulated photograph to a garden book or magazine publisher for an editorial feature. Be honest, and always label your digitally manipulated garden photographs accordingly.

BACKLIGHT AND SIDELIGHT

Although I generally dislike direct frontal sunlight as a light source for garden photography, I enjoy the dramatic lighting created by shooting directly into the light, or when direct sunlight illuminates a subject from the side. Backlight creates silhouettes, and glows around the edges of flowers and other garden subjects, while sidelight accentuates the forms of trees, buildings, and other structures. Photographs 43 and 44 illustrate the effects of backlighting and sidelighting. You'll need to increase your metered exposure by 0.5–1.5 stops with this type of lighting. In addition, be sure to use a lens hood to minimize the effect of flare, especially with zoom lenses. If you don't have a lens hood, you can use your hand to cast a shadow on the front of the lens. Look through the viewfinder when you do this to make sure that your hand isn't causing the edge of the image to vignette.

CLOUDY LIGHT VERSUS SHADE ON A SUNNY DAY

You might imagine that there is no difference between a garden scene under a cloudy sky and the same scene in the shade on a sunny day. In fact, these lighting conditions vary considerably, with respect to both quality and color rendition.

On a cloudy bright day, the sky acts as a giant diffuser, allowing light to penetrate into virtually all areas of a garden, except the very shady areas under rocks, trees, and shrubs. The white light from the sky also has minimal impact on the colors of the scene. On the other hand, light from a blue sky reflected into a shaded area is still somewhat directional, and the blue coloration has a definite cooling effect on the colors in the garden. I generally prefer the more subtle, uniform light of a cloudy day, although I will photograph a garden in shady sunlight if there are no other options and cloudy weather isn't in the forecast.

43. Tree sculpture, Toledo Botanical Garden, Ohio. Nikon F100, 24–120 mm Zoom-Nikkor, Fujichrome Velvia, Gitzo 340G tripod. This silhouette of a tree, sculpted by Carl Floyd, was cut from a 20-foot slab of steel plating recycled from lake freighters, truck trailers, and a nuclear power plant. I adjusted the exposure to preserve the dark silhouette against the sky.

44. Morning light in woodland, Schoepfle Arboretum, Birmingham, Ohio. Nikon 8008s, 24–120 mm Zoom-Nikkor, Fujichrome Velvia, Gitzo 320 Studex tripod.
Early morning sunlight can be dramatic in a woodland, especially if the sun is at an angle that produces strong shadows from the tree trunks. In this type of situation you must work quickly, though, because within a few minutes the strong lighting will become too garish and the pattern of light and shade too confusing. As with backlit scenes, add 1 or 1.5 f-stops of additional exposure to the metered reading to guard against underexposure.

MIST, FOG, AND RAIN

Mist and fog invariably get my landscape photography juices flowing! I love the soft, ethereal mood they create, and the low contrast makes it easy to capture the full tonal scale of highlight and shadow detail. Mist also often covers up a host of ugly man-made structures like power lines and cell phone towers, which I prefer to exclude from my landscape photographs. Just remember to open up 0.5–1.5 stops to retain the luminosity of the scene—mist and fog act like snow in this regard and need extra exposure to preserve the light, misty tones.

I also enjoy photographing gardens after a gentle shower, or even during one, provided it isn't raining too hard, which not only makes it difficult to keep the camera dry but also causes flowers and leaves to move due to the impact of raindrops. Light rain can imbue a garden with luminous, pearly

45. Oaks in morning mist, Stan Hywet Hall and Gardens, Akron, Ohio. Nikon 8008s, 24–120 mm Zoom-Nikkor, Fujichrome Velvia, Gitzo 320 Studex tripod. The early morning sun was rising through the mist on this frosty fall morning. It's very easy to underexpose back-lit, silhouetted scenes like this, so be sure to give 0.5–1.5 f-stops of additional exposure to compensate and preserve the soft, ethereal light.

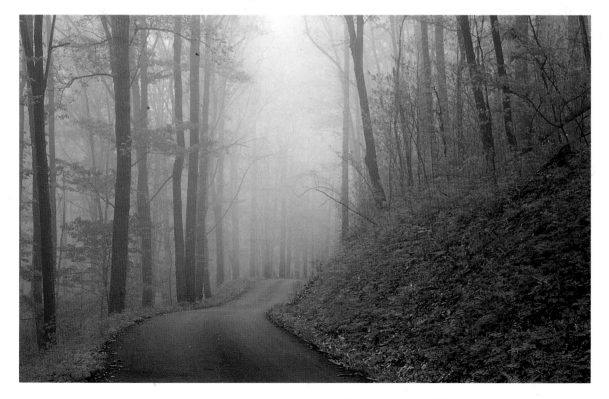

46. Misty country road, Shawnee State Forest, Scioto County, Ohio. Nikon F100, 24–120 mm Zoom-Nikkor, Fujichrome Velvia, Gitzo 340G tripod. The early morning mist provided many inviting compositions on a drive through Shawnee State Forest.

light that photographs beautifully with saturated films like Fujichrome Velvia. And early morning dew or raindrops on flower petals look great in flower portraits.

Although it's possible to use plastic bags and similar "rain protection" placed over camera and lens to ward off raindrops, I prefer to work under a large umbrella. It's awkward trying to adjust camera settings while holding an umbrella, so you might have a friend or spouse hold it for you, or rig a clamp to attach the umbrella to the tripod.

FLASH, REFLECTORS, AND DIFFUSERS

I must confess that I'm no lover of flash lighting, especially for nature and garden photography. Flash, at least direct flash, has many of the harsh characteristics of direct sunlight. Neither condition provides the soft diffuse light that complements the subtle tones, forms, and textures in most garden scenes. In addition, at least with film cameras, there is no way to preview the effect of using flash other than by using a Polaroid back on the camera, which is an expensive, time-consuming proposition that doesn't provide a true color preview. Digital cameras do provide instant feedback, but the subtle effect of the flash can be difficult to judge on small reflective monitor screens.

Fill-flash can sometimes be useful for garden portraiture, or to open up shadow areas, even on cloudy days. I usually dial in a setting of -1 or -1.5 f-stops, which provides a subtle level of fill light. I also frequently use a ringlight, which provides diffuse light, to photograph butterflies and dragonflies in garden settings. This technique is explored in Chapter 10.

Reflectors and diffusers, used in conjunction with natural light, can be very useful in plant portraits and other close-ups. A small gold reflector can be used to bounce a little light onto a flower to warm it up and make it stand out from the background, and silver reflectors are also available. Similarly, a large diffusing screen can facilitate close-up photography on a bright sunny day by diffusing the direct sunlight. These techniques also have the great advantage of allowing you to preview the effect through the camera's viewfinder.

SCOUTING AND PREPARING THE GARDEN

Some of my most memorable moments in gardens have been enjoyed not behind the camera but in the company and conversation of garden owners and designers. I strongly urge you to take a stroll around a garden with the garden owner or designer before taking any photographs, if time permits. There is no finer way to gain an understanding of the history and evolution of the garden, its design, the plants and structures within it, and the part it plays in the life of the owner and other visitors.

I fondly recall the first time I met garden designer Valerie Strong in her charming, free-spirited garden in Hudson, Ohio. As we strolled around the gravel paths past beds of irises, sweet alyssums, poppies, and ox-eye daisies, I noticed a cottontail rabbit munching a lettuce in the vegetable garden. "Valerie!" I cried. "There's a rabbit eating in your vegetable garden!" "Yes, Ian," she replied, serenely. "I plant enough for the rabbits, too." This experience taught me much about Valerie's reverence for nature and all God's creatures, and I've been entranced by her gardens ever since. If you want to better understand a garden, spend time with the garden owner.

I like to take a camera with my 24–120 mm Zoom-Nikkor lens as I stroll around a garden with the owner, but initially I leave my tripod and camera bag in my vehicle. I'm not taking photographs at this stage but simply previewing them. This is where a wide-angle to medium telephoto zoom lens is so useful. With it, you can preview establishing shots, attractive combinations of plants, and individual flowers that might make good subjects for close-ups.

GARDEN PREPARATION

Just as a model must be made up and dressed for a fashion show, a garden must be prepared for a photography session. Begin by sweeping garden paths and cleaning any dirt, bird droppings, or other debris from garden ornaments

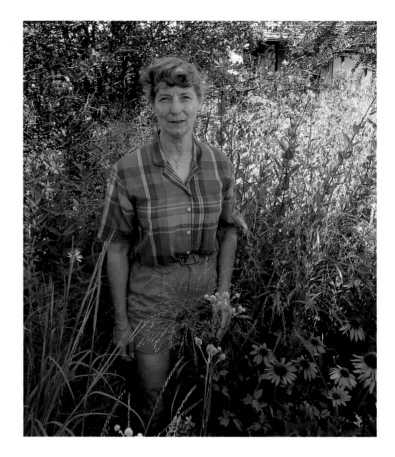

47. Pat Armstrong in her prairie garden, Naperville, Illinois, July. Nikon 8008s, 24–120 mm Zoom-Nikkor, Fujichrome Velvia. Pat Armstrong has literally grown an Illinois tallgrass prairie around her home in the suburbs of Chicago. At the height of the summer blooming period, more than seventy varieties of prairie plants may be blooming in a single day. To help control weeds, Pat burns the prairie each spring.

and furniture. If the garden has lawns, make sure they are freshly mowed and edged, and deadhead and trim flowers and shrubs. Remove any plant labels, making sure to remember where they came from so that you can return them after the photography session. Also remove any toys, garden hoses, or other objects that you don't want included in your photographs. Make sure any ponds and swimming pools are free of dirt, floating leaves, and so forth, and that waterfalls or other water features are fully operational. Arrange garden furniture and any other accessories, and confine any pets that might interfere with your work.

If you are fortunate enough to be able to photograph the garden following a rain shower, the stonework and any rocks will be nicely dampened, which brings out their true color. If not, use a hose to wet down the stonework of paths and other areas with bright highlights. I like to wait until the rocks are tacky rather than dripping with water. On a hot day, you may need to repeat the hosing down several times to keep the stonework damp. A polarizing filter will further saturate the color in damp rocks and bricks.

DOCUMENTS AND LABELS

If you are photographing a garden on assignment for a garden publication, garden designer, or other client, make sure that you understand requests for specific garden features to be photographed and that you are able to locate these. Also make sure that the garden owner completes and signs a property release.

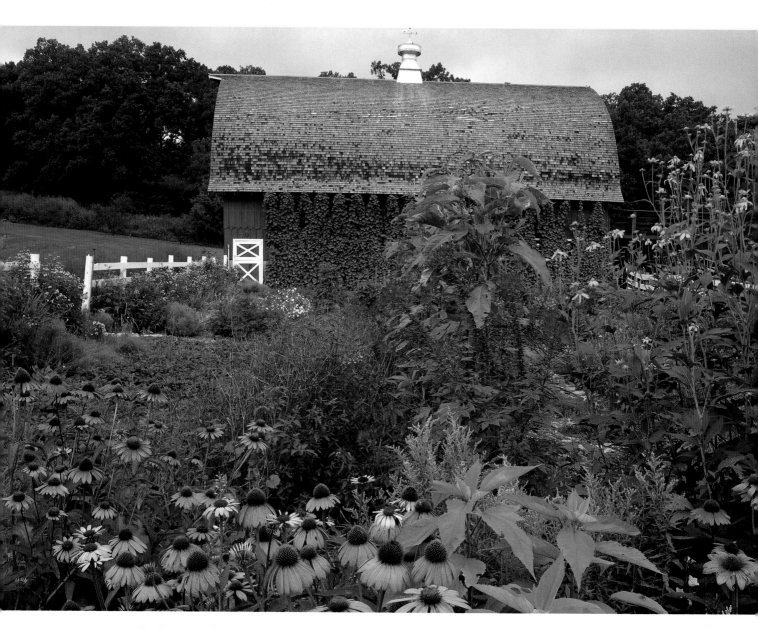

51. Display gardens and Amish-built barn at Seed Savers Exchange, Decorah, Iowa, August. Fuji GX680, 65 mm lens at f/32, Fujichrome Velvia, Gitzo 340G tripod, polarizing filter. Seed Savers Exchange, founded by Kent and Diane Whealy in 1975, is among the world's largest repositories of heirloom flowers, fruits, and vegetables. The camera was positioned close to a picket fence and adjusted to include only a thin sliver of the diffuse sky. The wide-angle lens was tilted forward a few degrees to bring the purple coneflowers and barn roof into focus, and the lens was stopped down to f/32 to maximize the vertical depth of field. The soft cloudy light eliminated harsh shadows, and a polarizing filter increased color saturation throughout the image. The lines of the coneflowers and picket fences help to draw the viewer's eye into the scene.

This classic, near-far, foreground-in-your-face approach to scenic photography using a wide-angle lens isn't new. Renowned landscape photographer Ansel Adams (no relation!) used it often, and it is the hallmark of many top contemporary landscape photographers, including David Muench, Carr Clifton, Larry Ulrich, Tom Till, Jeff Gnass, and Jack Dykinga. Studying the work of these talented photographers will provide you with many insights that you can incorporate into your garden photography.

Precise positioning of the camera is critical. At first, remove the camera from the tripod so that you can move it freely, trying various compositions until you find a promising design. Then, based on your viewing position, set up the tripod and reattach the camera. Pay special attention to the edges and corners of the image, making sure that no twigs, leaves, or other objects intrude to impair the composition. Make sure you examine the relationship of the various picture elements to ensure that important objects don't merge or overlap in the scene. A movement of the camera just an inch or two can have a profound effect on the final image. Take your time!

Precise focusing and depth-of-field control are also critical elements in garden vistas. It is important that the foreground subject be rendered tack-sharp, and ideally the entire scene should be in focus. If necessary, sacrifice a little sharpness in the distance, but keep the foreground elements sharp. This means using the hyperfocal-distance approach to focusing (see Chapter 4) and a small f-stop such as f/16 or f/22. Remember to use your camera's depth-of-field preview control, if you have one, to ensure that everything will be in sharp focus when the lens is stopped down.

CHOOSING YOUR VIEWPOINT

Choosing the best vantage point from which to photograph a garden is another important decision. A high viewpoint, such as from a balcony, upstairs window, or flat roof, often reveals the underlying geometry and design of the garden. If there are no buildings or suitable vantage points near the garden, a stepladder may be needed. Sometimes you'll need to use a wide-angle lens setting to encompass the scene, while on other occasions a normal or even telephoto setting on your zoom lens will be needed.

A low viewpoint can be very useful for compressing perspective, disguising patches of bare earth or mulch, and photographing tall objects against the sky. In particular, snow-covered trees, tall prairie plants, and fall foliage can be dramatic when photographed against a blue sky or sunlit storm clouds. Occasionally pointing the camera straight up in a grove of trees creates a cathedral effect that can be very appealing.

52. English Garden, Stan Hywet Hall and Gardens, Akron, Ohio, July. Nikon 8008s, 24–120 mm Zoom-Nikkor at f/16, Fujichrome Velvia, Gitzo 340G tripod.
I used a wide-angle setting on my Zoom-Nikkor lens to capture this overview of the English Garden, designed by the popular American landscape designer Ellen Biddle Shipman. The tripod was set up on the wall that surrounds the sunken garden, providing an aerial perspective that highlights the formal geometry of the garden design. The camera was tilted to just include the roof of the doorway entrance.

53. English Garden, Stan Hywet Hall and Gardens, Akron, Ohio, May. Nikon 8008s, 24–120 mm Zoom-Nikkor at f/22, Fujichrome Velvia, Gitzo 340G tripod.
I used a wide-angle setting of about 28 mm on my Zoom-Nikkor lens and positioned the camera to fill the foreground with peonies, one of my favorite flowers. The strong pink of the peonies contrasted well with the greens and soft pastels that form the predominant color scheme in the garden. The point of focus was just beyond the peonies, and the lens was stopped down to f/22 to maximize depth of field.

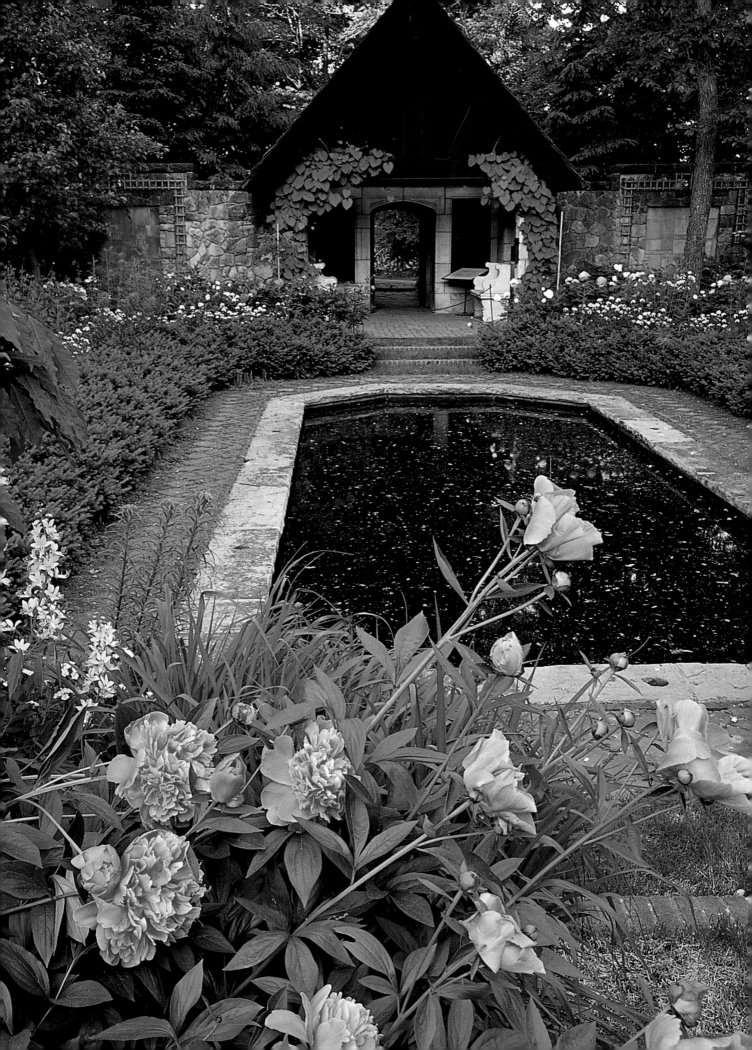

Using garden objects as framing elements, especially tree or shrub foliage, is an effective way to direct the attention of the viewer to the key subject in the photograph. Photograph 54 illustrates how framing elements can be used to focus your attention on the subject.

Another important compositional device is the use of leading lines to draw the viewer's eye into the scene. Photograph 55 is an excellent example of how multiple leading lines can serve to focus your eye and make you wonder, "What's around the bend?"

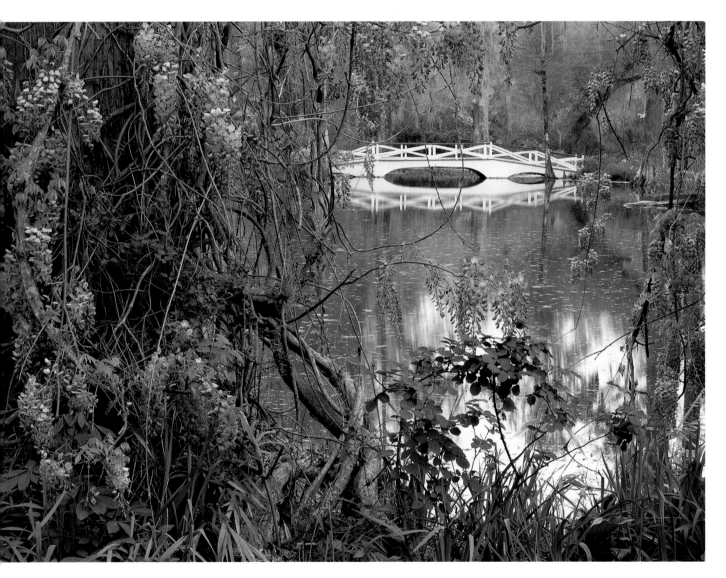

54. Wisteria and bridge, Magnolia Plantation, Charleston, South Carolina, April. Fuji GX680, 100 mm lens at f/32, Fujichrome Velvia, Gitzo 340G tripod. Founded in 1676, Magnolia Plantation showcases one of the oldest public gardens in America, open to the public since the late 1860s, when the Reverend John Grimke Drayton laid out paths and planted hundreds of Indica azaleas and camellias, a symbol of the old South. In this photograph I used the wisteria to frame the historic bridge, which was positioned using the rule of thirds. The overcast light necessitated a shutter speed of several seconds, and I had to wait for several minutes for the wisteria to stop moving in the breeze. When I returned a year later there was no sign of the wisteria. A gardener informed me that it had been cut down "to improve the view."

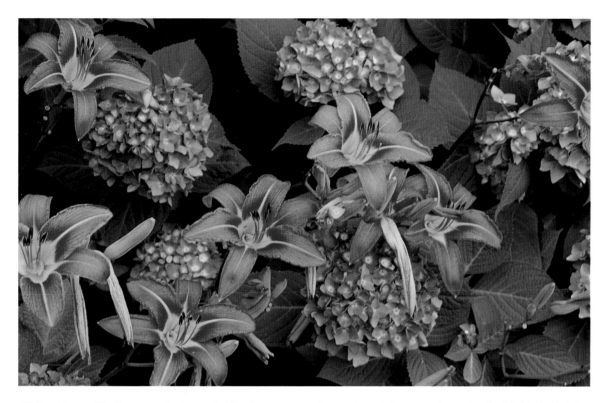

67. Daylilies and hydrangeas, Portsmouth, Rhode Island, June. Nikon F100, 24–120 mm Zoom-Nikkor at f/11, Fujichrome Velvia, Gitzo 340G tripod. This image was made with the camera mounted on a tripod, focused carefully to maximize depth of field. The bright orange of the daylilies contrasts vividly with the blue of the hydrangeas.

68. Daylilies and hydrangeas, Portsmouth, Rhode Island, June. Nikon F100, 24–120 mm Zoom-Nikkor at f/22, Fujichrome Velvia. Feeling somewhat free-spirited after a few glasses of wine, I handheld the camera and gently jiggled it during a multisecond exposure.

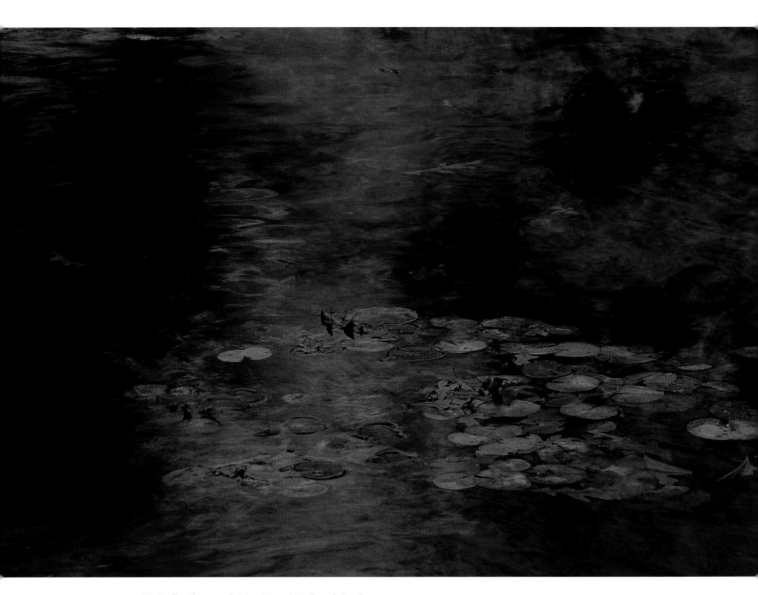

69. Reflecting pool, Stan Hywet Hall and Gardens, Akron, Ohio, November. Nikon 8008s, 24–120 mm Zoom-Nikkor at f/11, Fujichrome Velvia, Gitzo 340G tripod. A fountain created impressionistic swirls in a reflecting pool that mirrored the brilliant red foliage of Japanese maples. I experimented with a variety of slow shutter speeds, around 1/4–1/2 second, and picked as my favorite this photograph, which was reproduced across two pages in *Stan Hywet Hall and Gardens* (2000). I call this image my "Monet moment."

Compositional Guidelines

I have reviewed thousands of close-ups during more than a hundred photography workshops, and I have noticed four common mistakes made by most inexperienced photographers when composing these shots: using inappropriate lighting for the subject, selecting an inappropriate background, centering the subject, and making the subject too small in the picture frame.

We've already discussed lighting for close-up photography, and I hope that I've convinced you to prefer—or to create—diffuse light and to avoid bright contrasty light.

Arranging an appropriate background for the subject is a critical element in close-up photography. In particular, try to ensure that the background is sufficiently out of focus so that it doesn't distract the viewer's attention from the subject itself. How do you ensure a blurred background? By using the longest lens possible (preferably a 180 mm or 200 mm macro lens, or a 70–210 mm zoom with a close-up filter) and positioning the camera carefully so that the minimal amount of stopping down is needed to produce a subject that is sharp. If f/8 is sufficient to render the flower sharp, don't use f/11 or f/16—you'll need to use a slower shutter speed and the background will become less diffuse.

The tone and color of the background, relative to that of the subject, are also critical elements. Light subjects, such as white or yellow flowers, stand out better against dark backgrounds, while dark flowers require a light background. Similarly, try to pick background colors that are complementary to the color of the subject. A red rose, for example, contrasts beautifully with green foliage, and a yellow flower stands out nicely against a blue sky.

To center, or not to center (the subject, that is): that is the question.

Those who are new to floral close-up photography usually position the flower exactly in the middle of the picture frame. This is a weak, static placement, especially when the flower is small relative to the size of the photograph. The only time that it makes sense to place a flower dead center in the picture frame is when you are filling the frame with the flower and there's nowhere else to position it!

The rule of thirds provides a better basis for positioning most close-ups of single flowers. It isn't critical that the flower be placed exactly one-third of the distance from each edge—the idea is simply to move the flower away from the center, toward one of the corners a little, resulting in a stronger, more dynamic composition.

In general I try to avoid close-ups of two flowers, because the viewer's attention tends to bounce back and forth between each flower. If you must shoot two flowers, try to arrange them along a diagonal within the picture frame, and try to make one flower a little larger than the other. With three flowers, you'll want to explore compositions that exploit the curve that the flowers make.

72. Yellow flag (*Iris pseudacorus*), Nature Center at Shaker Lakes, Shaker Heights, Ohio, June. Nikon 8008s, 200 mm Micro-Nikkor at f/11, Fujichrome Velvia, Gitzo 340G tripod. A classic case of "bull's-eyeing," with the subject positioned smack dab in the center of the picture frame. Compositionally this is weak, though the photograph would work well if it was destined for use as a magazine cover in which the top part of the image is needed for the magazine logo!

73. Yellow flag (*Iris pseudacorus*), Nature Center at Shaker Lakes, Shaker Heights, Ohio, June. Nikon 8008s, 200 mm Micro-Nikkor at f/11, Fujichrome Velvia, Gitzo 340G tripod. This version would certainly win more kudos in camera club competitions and make a more interesting print. The iris has been moved away from the center, creating a stronger composition.

More Tips for Close-ups

One of my earliest assignments as a garden photographer was to photograph more than 250 varieties of shrubs and vines for a book project. Sometimes I photographed more than twenty species in a single shooting session, and keeping track of all the shrubs I had photographed became a challenge. The trick is to photograph the label of the plant before you photograph the plant itself (see also Chapter 6).

Long-stemmed plants present another challenge, as they tend to sway in the breeze, even on calm days. As described in Chapter 4, you can support these with cane stakes and twist ties, or with an extendable arm called a Plamp.

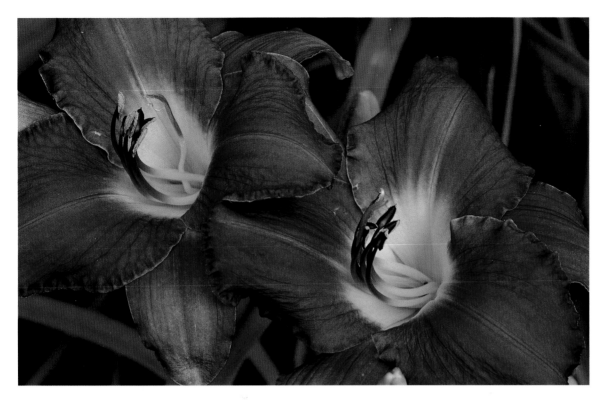

74. *Hemerocallis* 'Pewter Lake', Kingwood Center, Mansfield, Ohio, June. Nikon F100, 70–180 mm Zoom Micro-Nikkor at f/16, Fujichrome Velvia, Gitzo 340G tripod. I positioned these two attractive daylilies diagonally in order to more effectively fill the picture space than I could by aligning them with the edge of the frame. The diagonal placement is also a little more dynamic.

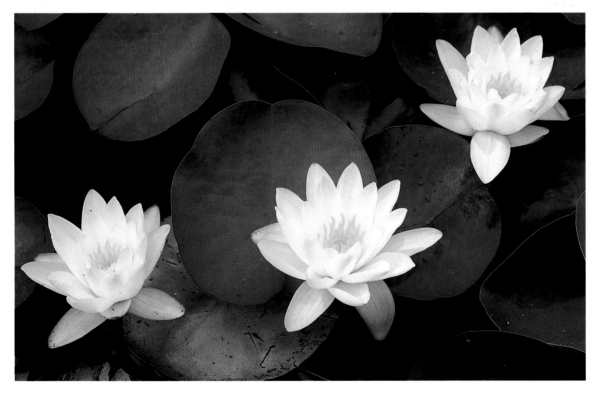

75. Water lilies, Stan Hywet Hall and Gardens, Akron, Ohio, July. Nikon 8008s, 200 mm Micro-Nikkor at f/16, Fujichrome Velvia, Gitzo 340G tripod. These three water lily blossoms provided an attractive compositional curve that makes effective use of the picture space. The diffuse light ensured that the delicate highlights and details of the blooms were retained.

9

GARDEN STRUCTURES

By February the gray skies and chill winds of late winter in northeastern Ohio have given me a bad attack of cabin fever. By early March I can stand it no longer, and one morning around this time I set off south on Interstate 77 through West Virginia in search of spring. By midday, after plunging down the Blue Ridge Mountains of Virginia on I-77 into the Piedmont of North Carolina, I begin to notice the first touches of green in the landscape, and a couple of hours later I am enjoying the vistas of Bradford pears, crabapples, cherries, and bright swathes of daffodils blooming along the roadsides near Charlotte, North Carolina. By early evening I've reached Charleston, South Carolina, or Savannah, Georgia, my two favorite garden photography destinations in early spring in the South. Although I'm captivated by the profusion of spring bulbs, azaleas, dogwoods, peaches, Cherokee and Lady Banksia roses, and wisteria in bloom at this time of year, it is the architectural settings of these elegant southern gardens that enthrall me.

Savannah was founded in 1733, designed by the English general James Oglethorpe on a precise rectangular grid of intersecting squares, many embellished with fountains, monuments, massive live oaks, and public gardens. Around the squares, in the prosperous years prior to the Civil War, wealthy cotton brokers and other business owners built stately town houses in Federal, Georgian, Gothic, Regency, and other architectural styles. In secluded courtyards, elegant gardens were established as places to entertain family and friends.

If Savannah has a rival, it must be Charleston, that quintessential southern city a scant 85 miles north, and slightly east, as the crow flies. Considered by many people to be the most beautiful city in the United States, Charleston has preserved an astonishing amount of its original colonial architecture, unsullied by modern high-rise buildings, which are confined to the northern, commercial section of the city. As you stroll the narrow cobblestone streets—don't even think of driving, especially during rush hour—you'll marvel at the

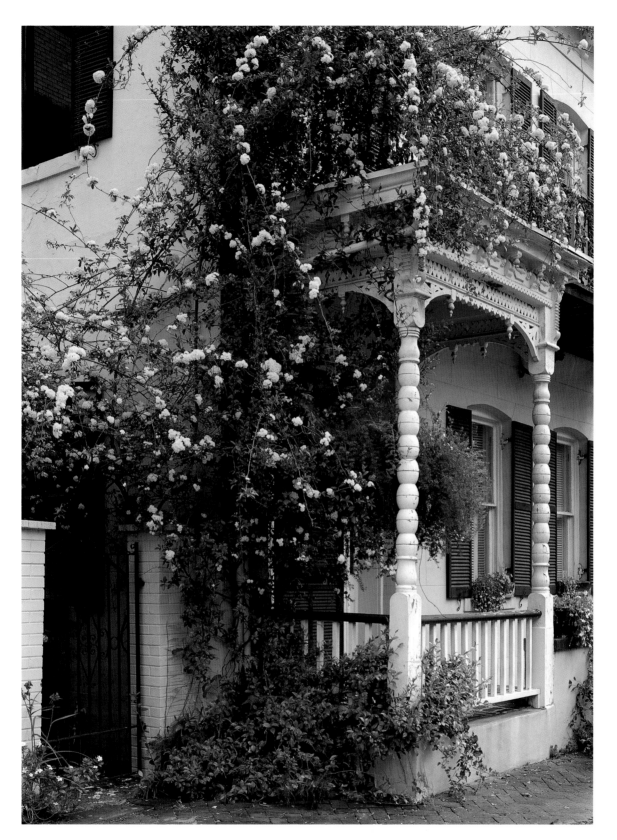

76. Lady Banksia roses (*Rosa banksiae*), Savannah, Georgia. Fuji GX680, 100 mm Fujinon, Fujichrome Velvia, Gitzo 340G tripod. The Lady Banksia rose is a floral delight in the South, where it flowers in early spring on buildings and fences in Charleston, Savannah, and other southern cities. The yellow variety has even been adopted as the "yellow rose of Texas," the official flower of the Lone Star State. The luxuriant shrub in this photograph was draped over the balcony of a townhouse in the old city of Savannah.

balustrades, colonnades, cupolas, entablatures, facades, lunettes, modillions, Palladian windows, parapets, pediments, piazzas, pilasters, porticos, tracery, and trefoils that adorn the town houses and city buildings. Every wrought-iron gate offers a tantalizing glimpse of a garden, enclosed between old, arched, vine-covered walls and filled with fountains, statues, painted iron benches and tables, and ornamental plants in vast clay pots.

In both cities, the gardens are an integral part of the architecture, making the best use of limited space, ensuring privacy, and utilizing plants that flourish in the long hot summers and mild winters that characterize the coastal lowlands of Georgia and South Carolina.

Although many of these city gardens are in private hands, a few can be viewed by the public, especially in spring, when the owners open their gardens for architectural and garden tours, usually given in March and April. If you are an aficionado of fine gardens and architecture—and here the two go hand in hand—treat yourself to a week in these two elegant southern cities in early spring at least once in your lifetime, and enjoy a few days in garden photography heaven. And don't forget the delicious seafood, cultural variety, and fine southern hospitality!

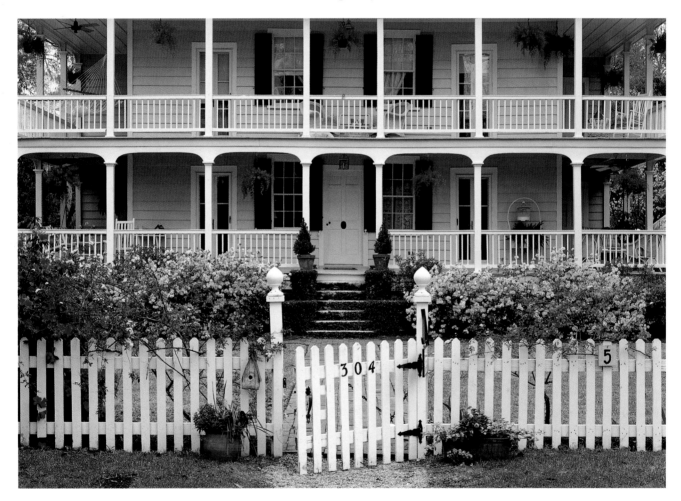

77. Picket fence and azaleas, Summerville, South Carolina. Fuji GX680, 65 mm Fujinon, Fujichrome Velvia, Gitzo 340G tripod. Early April is my favorite time to visit the "low country" of coastal South Carolina near Charleston. A few miles north of this gracious southern city is the village of Summerville, where I found this pastel composition of a white picket fence, azaleas, and a southern plantation home. A few miles south are the famous gardens at Middleton Place and Magnolia Plantation along the Ashley River.

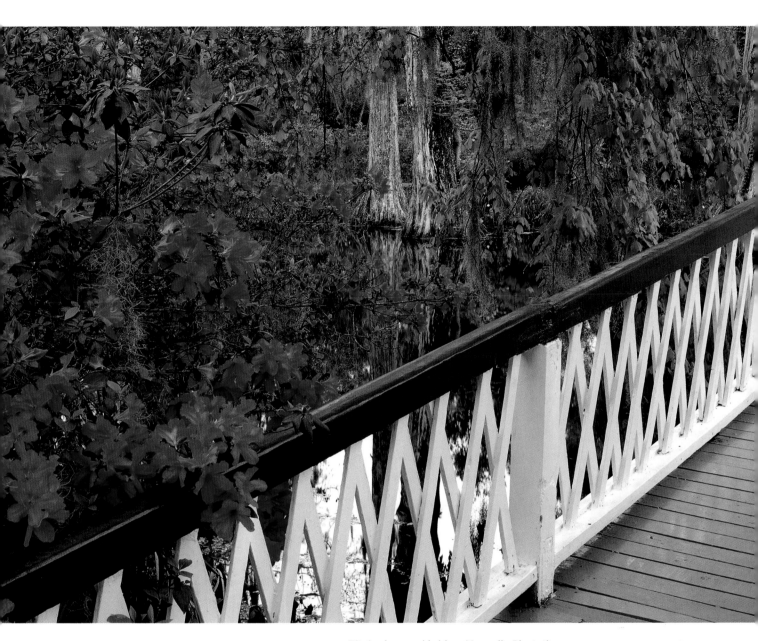

78. Azaleas and bridge, Magnolia Plantation, Charleston, South Carolina. Fuji GX680, 65 mm Fujinon, Fujichrome Velvia, Gitzo 340G tripod.
Although there is something in bloom every month at Magnolia, the gardens are at their most spectacular in late March and early April, when azaleas, camellias, wisteria, Cherokee rose, and spring bulbs are all in flower. In this photograph I framed the elegant old Long Bridge with an exuberant display of azaleas at the peak of their early spring bloom.

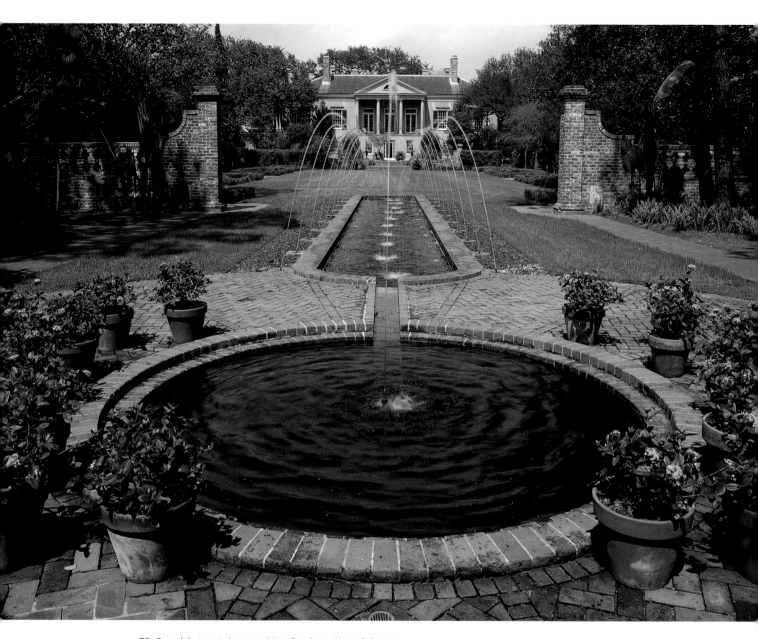

79. Spanish court, Longue Vue Gardens, New Orleans. Fuji GX680, 65 mm Fujinon, Fujichrome Velvia, Gitzo 340G tripod. The elegant Spanish court is the main attraction at Longue Vue, the opulent estate built by Sears Roebuck heiress Edith Stern and her husband, Edgar Stern, between 1939 and 1942 in the suburbs of New Orleans. The Sterns commissioned Ellen Biddle Shipman to plan the formal garden, which includes fountains similar to those of the Alhambra and Generalife in Granada, Spain. The water gardens were added in 1966 as part of a redesign by William Platt.

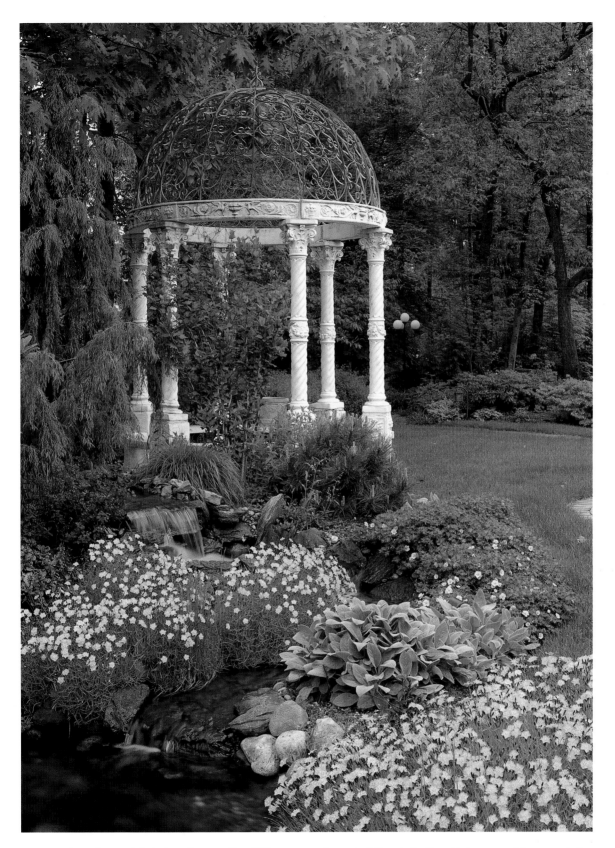

89. Pergola and waterfall, Bob and Jacqueline Gill's garden, Canton, Ohio. Fuji GX680, 100 mm Fujinon, Fujichrome Velvia, Gitzo 340G tripod. Garden designers Sabrena Schweyer and Samuel Salsbury designed the waterfall and plantings that surround the pergola in Bob and Jacqueline Gill's garden. Fuzzy lamb's ears (*Stachys byzantina* 'Big Ears') contrast with flowering cheddar pinks (*Dianthus gratianopolitanus* 'Bath's Pink').

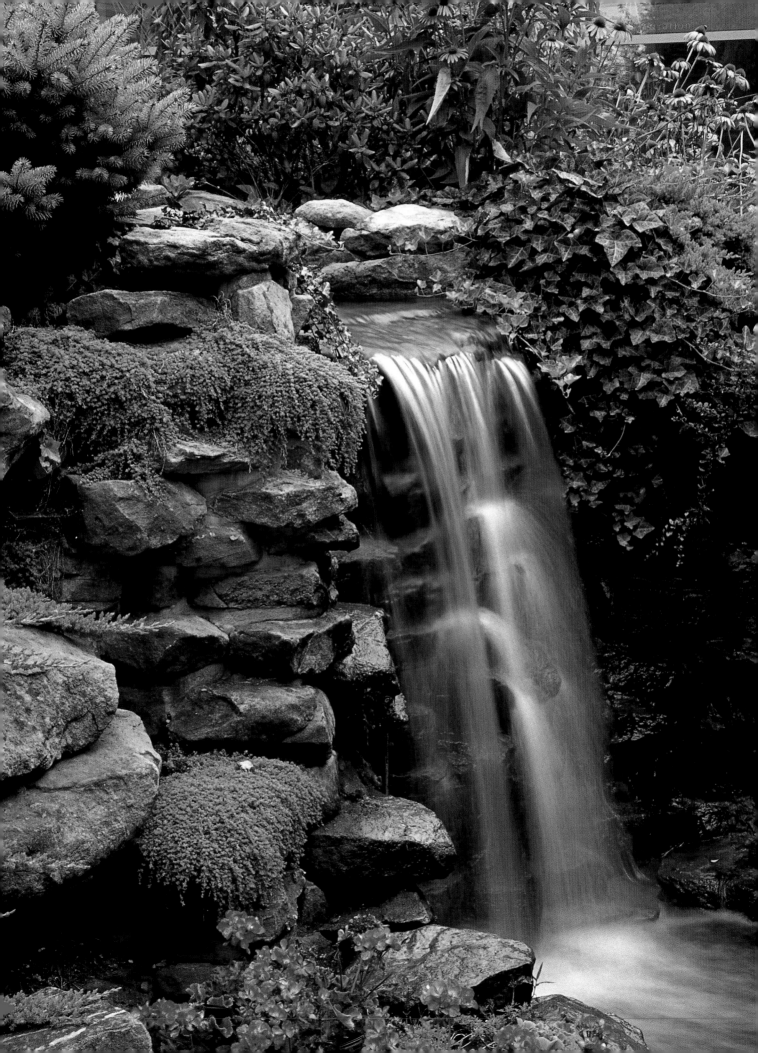

As the sumptuous perennial and annual entrées of summer gardens fade, nature gathers its strength for a grand floral dessert, as woodland gardens explode with the vivid hues of autumn color. Deep red Virginia creeper and Boston ivy vines embellish trees and buildings, and around wetland areas red maples glow like fire engines. By midautumn, the foliage of golden yellow tulip poplar, beech, and hickory softens the bright reds and oranges of sugar maple, red maple, sweet gum, sumac, sassafras, and scarlet oak. Fruits and berries of shrubs and trees are abundant in fall, providing additional subjects for the garden photographer—and don't forget the added attraction of farm produce.

Asters and Japanese anemones rub shoulders with chrysanthemums in the fall garden, together with autumn colchicums and even a few late-blooming roses. As with summer flowers, overcast weather provides my favorite lighting for photographing the delicate colors and textures of these autumn beauties. If you must photograph on a sunny day, try using a circular diffuser to soften direct sunlight and eliminate harsh shadows.

On frosty, sunny days, rise early to photograph the touches of frost on autumn foliage and flowers, and savor the weather fronts that can provide sensational lighting, especially when sunlit fall colors are etched against a dark stormy sky. Sunny weather also provides the best lighting for photographing reflections of fall foliage in lakes, rivers, and streams. The reflections are most dramatic when the fall color is sunlit and the water is in shade. Try using slow shutter speeds to create abstract patterns from fall foliage reflected in the moving water of rivers, streams, and fountains (for example, see Photograph 69).

124. Purple beautyberry (*Callicarpa dichotoma*), Holden Arboretum, Lake County, Ohio. Nikon F3, 105 mm Micro-Nikkor, Fujichrome Velvia, Gitzo 320 Studex tripod. Fruits and berries make colorful subjects in fall. I used a macro lens to isolate this group of purple beautyberries in Holden Arboretum's display garden.

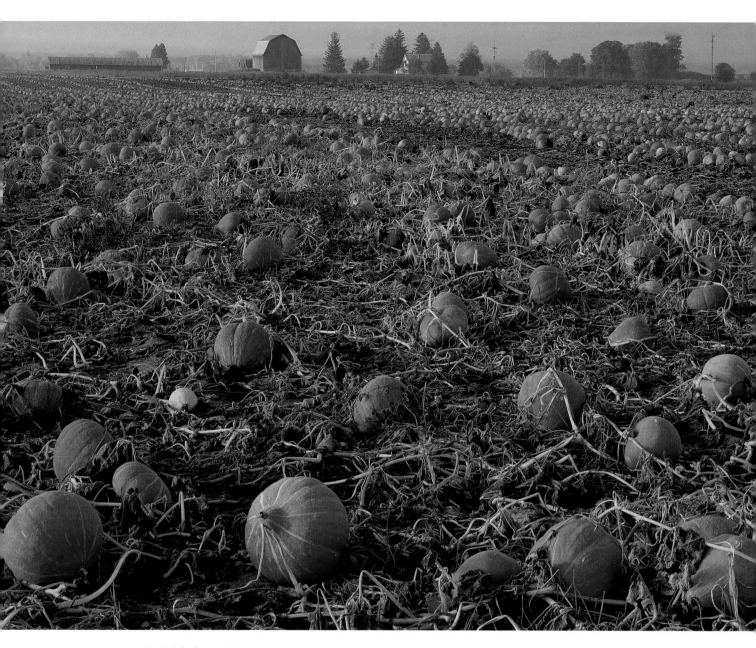

125. Field of pumpkins, near Pentwater, Michigan. Fuji GX680, 65 mm Fujinon, Fujichrome Velvia, Gitzo 340G tripod, polarizing filter. I was returning home in late afternoon from a fall color photography trip to the Upper Peninsula of Michigan when I came upon this vast field of pumpkins. I was so impressed by the photographic potential of the scene that I decided to delay my return to Ohio so that I could stay overnight at a local motel and visit the field the next morning at sunrise. The early sun, aided by Velvia film and a polarizing filter, rendered the pumpkins a rich reddish orange. I used a 65 mm wide-angle lens and a little lens tilt on my Fuji GX680 6 × 8 cm view camera to ensure sharp focus throughout the scene, and lowered the camera to eliminate all but a sliver of the hazy morning sky, further accentuating the size of the pumpkin field.

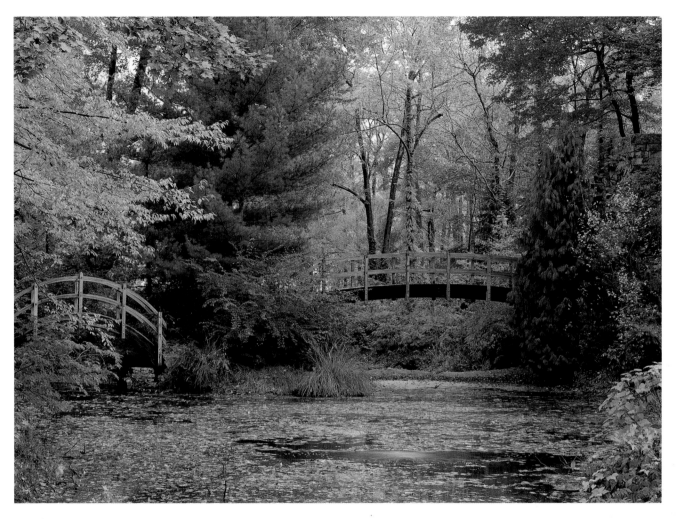

126. Fall color in the lagoons, Stan Hywet Hall and Gardens, Akron, Ohio. Fuji GX680, 100 mm Fujinon, Fujichrome Velvia, Gitzo 340G tripod, polarizing filter. These lagoons are the remains of quarries where sandstone blocks were cut to help build the Manor House and other structures at Stan Hywet Hall and Gardens. Paths wander the edges of the ponds that have filled the old quarries. I enjoyed the contrast between the maples and conifers framing the two small footbridges in this remote area of the gardens. A polarizing filter helped to further intensify the colors.

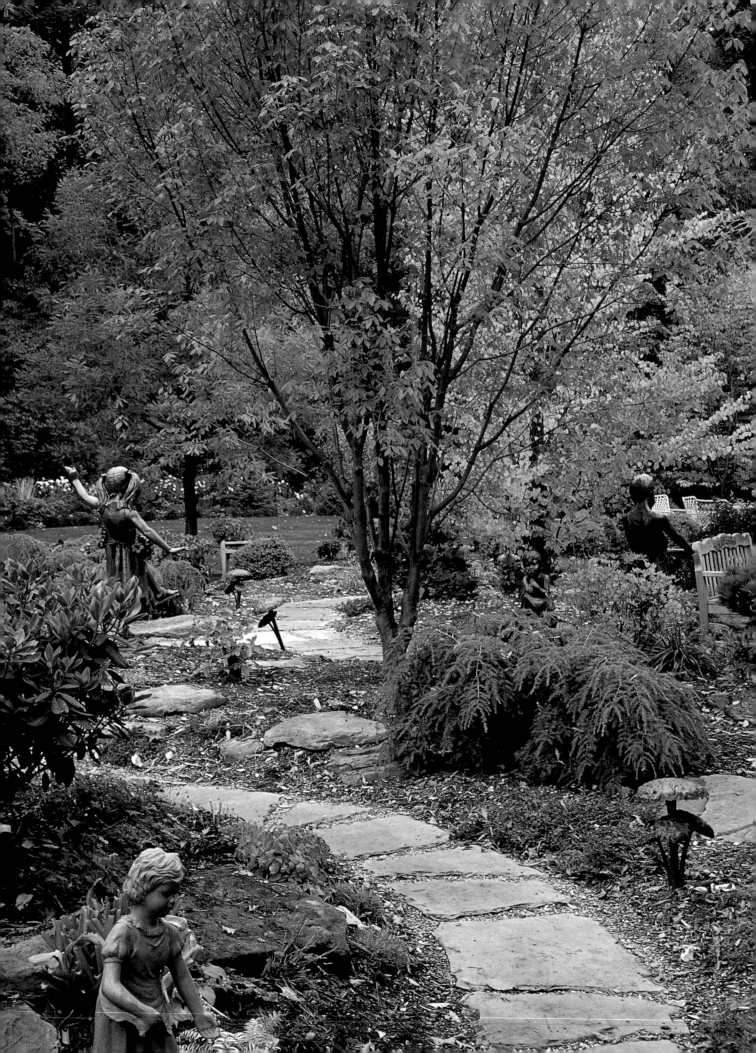

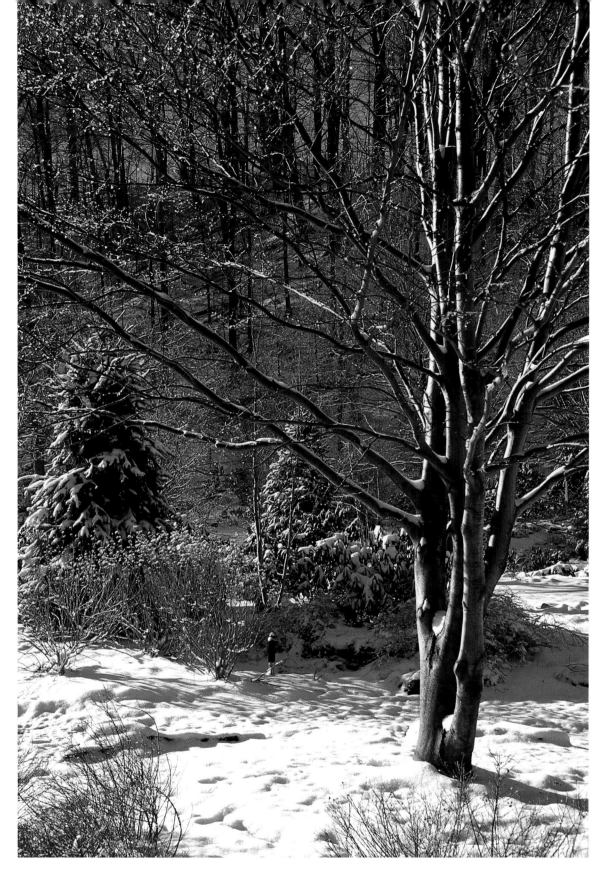

130. Late winter snowfall, Mimi Gayle's garden, Kirtland, Ohio. Nikon F100, 24–120 mm Zoom-Nikkor, Fujichrome Velvia, Gitzo 340G tripod. In northeastern Ohio, early and late snowfalls—usually in November or December and March or April, when temperatures are moderate—often allow the snow to stick to trees and other garden objects, creating photogenic conditions for winter garden photography. You may need to work quickly, though, because thawing temperatures often melt the snow in short order.

13

FINDING FINE GARDENS
TO PHOTOGRAPH

Canada and the United States are blessed with an abundance of public and private gardens, a cornucopia of riches for the garden photographer. Although the blooming period for gardens is limited to a few months in most of Canada and part of the northern United States, you can find trees, shrubs, and flowers in bloom throughout the year in the southern United States. From the arctic and alpine zones of the Canadian arctic and Rocky Mountains to the subtropical zones of Florida and Hawaii, this region provides the garden photographer a lifetime of photogenic opportunities.

PUBLIC GARDENS

The *National Geographic Guide to America's Public Gardens* (Jenkins 1998) is a comprehensive guide to three hundred gardens in North America. *Gardens of North America and Hawaii* (Jacob and Jacob 1985) lists more than fourteen hundred public gardens in the United States and Canada; though out of print, it is obtainable from some used garden book suppliers.

Another excellent source of information is the American Association of Botanical Gardens and Arboreta (AABGA), which publishes a monthly newsletter and a quarterly journal, *The Public Garden*. AABGA also sponsors six regional meetings and a national conference each year.

Most public gardens allow photography, but a growing number, especially grand estate gardens, such as Longwood, Dumbarton Oaks, Biltmore Estate, and Vizcaya, have restrictions and rules that must be observed by photographers. Some of the rules restrict the use of tripods, unless a tripod permit is obtained in advance. Other regulations govern the use of photographs. Longwood Gardens, for example, requires a tripod permit, which must be attached to the tripod at all times, and recognizable photographs of the garden are not allowed for commercial use, such as in an advertisement, without

written permission from Longwood's public relations department. On the other hand, you are free to take close-up photographs of trees, shrubs, and flowers for stock usage.

A growing trend, especially at the larger grand estate gardens, is the practice of charging photographers a fee for photographing the garden. This is an understandable action, since gardens are faced with the continuing challenge of raising funds for maintenance and other services. A few gardens, however, have seen fit to demand excessive fees. I was once asked to pay $150 per hour for the privilege of taking photographs in a public garden in Florida. Needless to say, not being independently wealthy, I declined.

Courtesy and common sense usually pay dividends when trying to negotiate access and permission to photograph in public gardens. For example, if you are photographing for a book project or magazine article, obtain a letter of introduction from the publisher and write a letter to the public relations manager of the garden to request permission to visit and take photographs. Few public gardens will object to free publicity in a book or magazine. In addition, I always send the public relations department a set of duplicate 35 mm color slides or digital files of the best photographs taken during my visit, for use at no cost in the garden's internal brochures or other publications. I also produce and donate inkjet color prints to many of the public gardens I am privileged to visit and photograph.

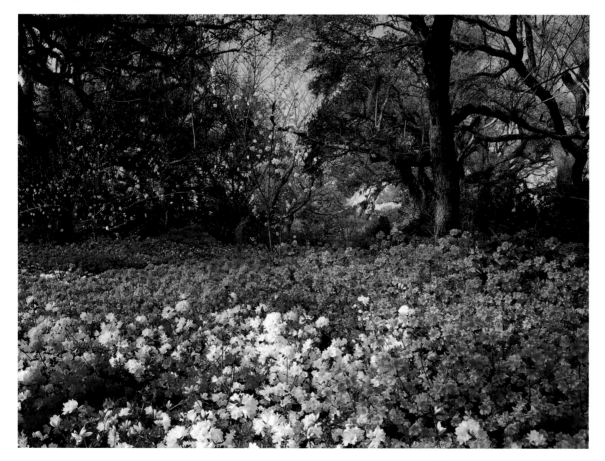

131. Azaleas, Orton Plantation Gardens, Winnabow, North Carolina, April. Fuji GX680, 65 mm lens at f/16, Fujichrome Velvia, Gitzo 340G tripod. These 20-acre gardens were established by the Sprunt family in the early 1900s around an antebellum plantation house. They are at their best in spring when the azaleas are in bloom.

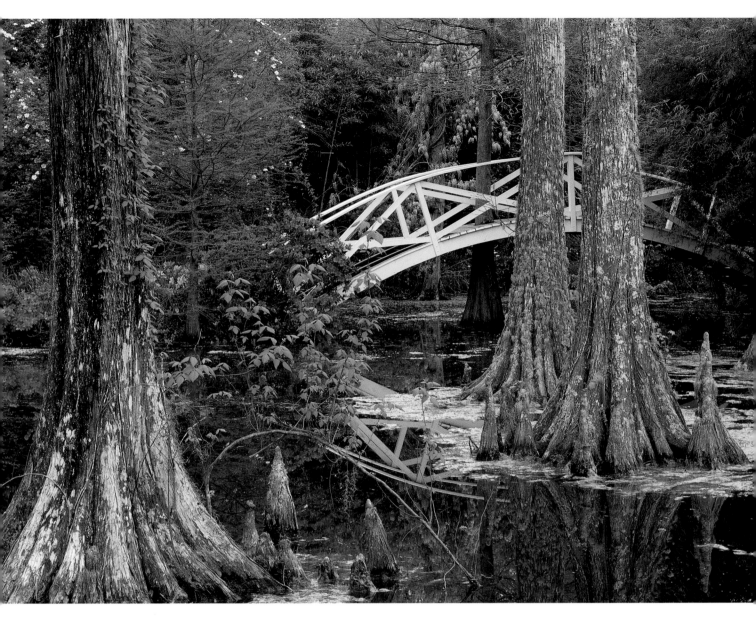

132. Cypress, azaleas, and footbridge, Magnolia
Plantation, Charleston, South Carolina, April. Fuji
GX680, 100 mm lens at f/22, Fujichrome Velvia, Gitzo
340G tripod. At this classic antebellum garden,
thousands of azaleas bloom alongside Spanish
moss–covered bald cypress trees scattered among
the lagoons.

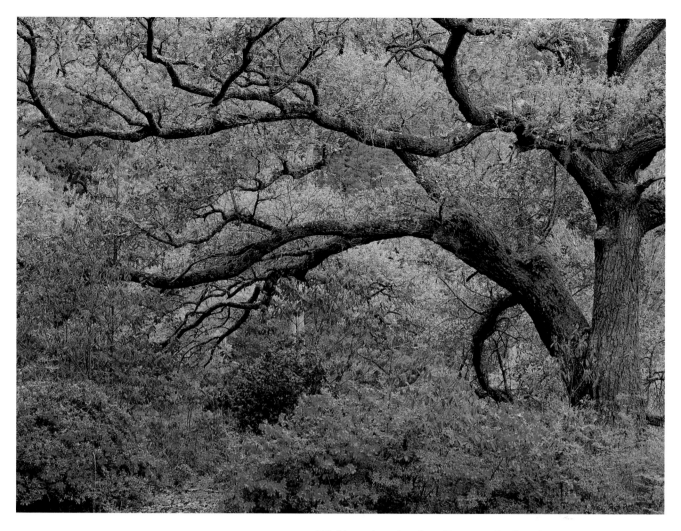

133. Live oak and azaleas, Zemurray Gardens, Loranger, Louisiana, March. Fuji GX680, 135 mm lens at f/22, Fujichrome Velvia, Gitzo 340G tripod. Samuel Zemurray parlayed Central American bananas into a $33 million fortune in the 1920s before establishing Zemurray Gardens at an old plantation. Camellias, azaleas, dogwoods, and magnolias line the paths around Mirror Lake.

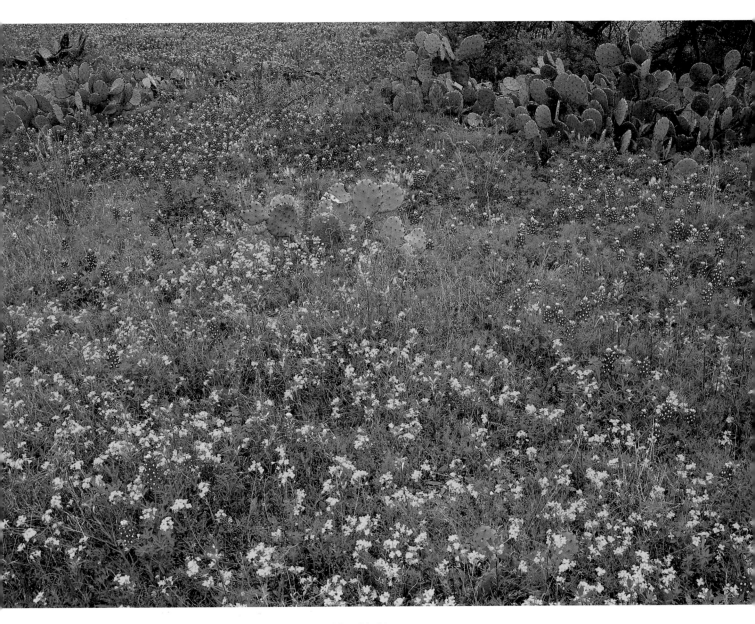

134. Texas bluebonnets, paintbrush, and low bladder-pod, Llano County, Texas, April. Fuji GX680, 65 mm lens at f/16, Fujichrome Velvia, Gitzo 340G tripod. Each spring, the Texas Hill Country bursts into color as dozens of wildflower species put on a spectacular display.

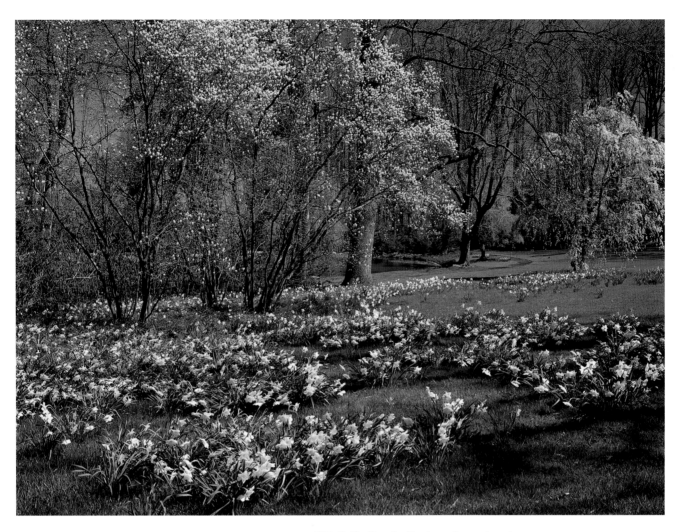

135. Daffodils, shadbush, and weeping cherry, Longwood Gardens, Kennett Square, Pennsylvania, April. Fuji GX680, 65 mm lens at f/16, Fujichrome Velvia, Gitzo 340G tripod, polarizing filter. The woodlands, lakes, fountains, statues, and plantings of Longwood Gardens offer a visual feast each month of the year.

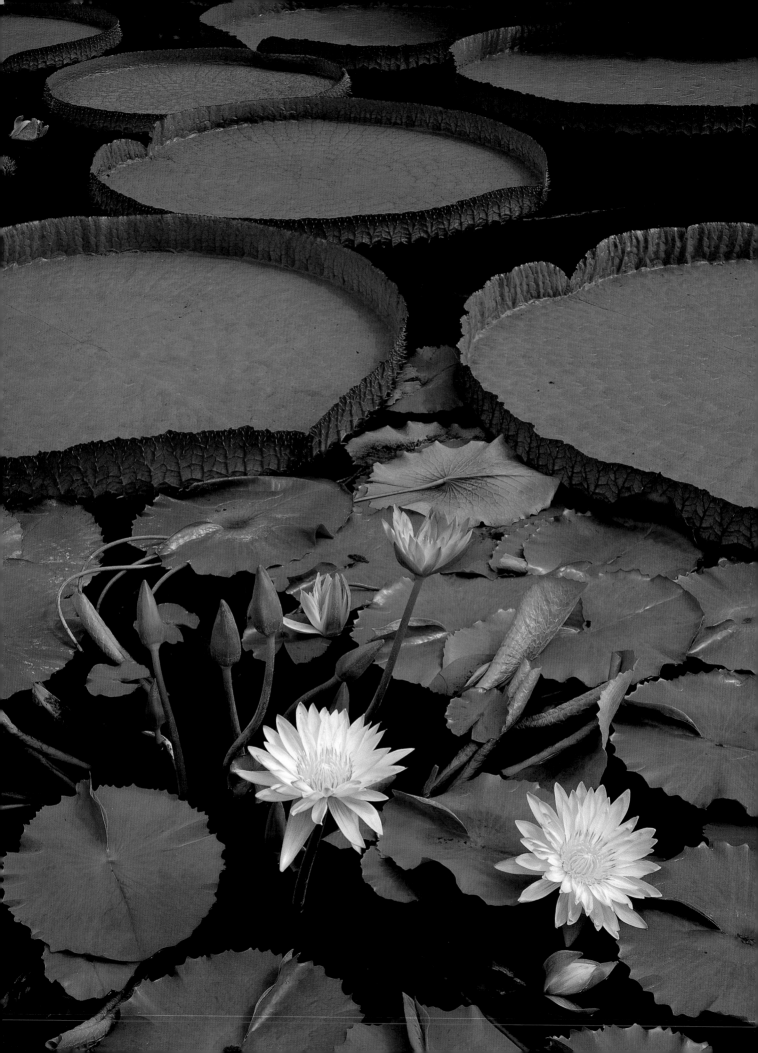

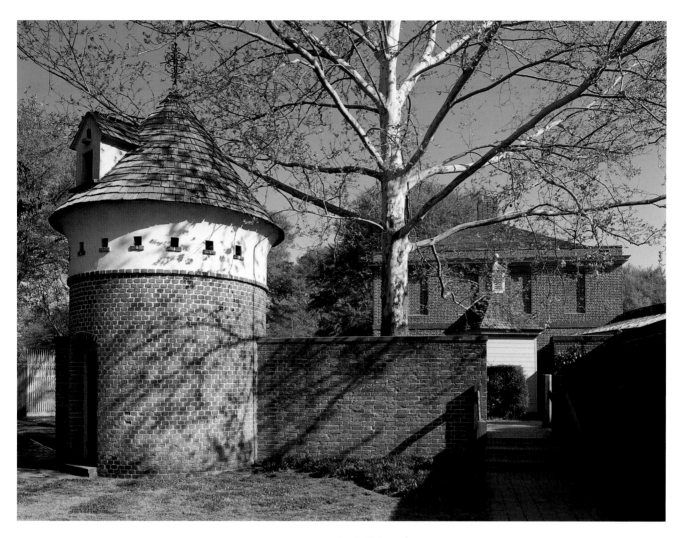

137. Outbuildings at Tryon Palace, New Bern, North Carolina, April. Fuji GX680, 100 mm lens at f/16, Fujichrome Velvia, Gitzo 320 Studex tripod. The gardens at Tryon Palace encompass 14 acres of parterres, garden rooms, lawns, and walkways surrounding a reproduction of the English "palace" built in the 1770s for North Carolina's Royal Governor William Tryon. The original building was almost destroyed by fire in 1798.

136. Giant water lily (*Victoria amazonica*) pads, Longwood Gardens, Kennett Square, Pennsylvania, September. Fuji GX680, 65 mm lens at f/22, Fujichrome Velvia, Gitzo 340G tripod. These giant water lily leaves, up to several feet across and capable of bearing the weight of a child, are among the summer highlights in the Conservatory at Longwood Gardens.

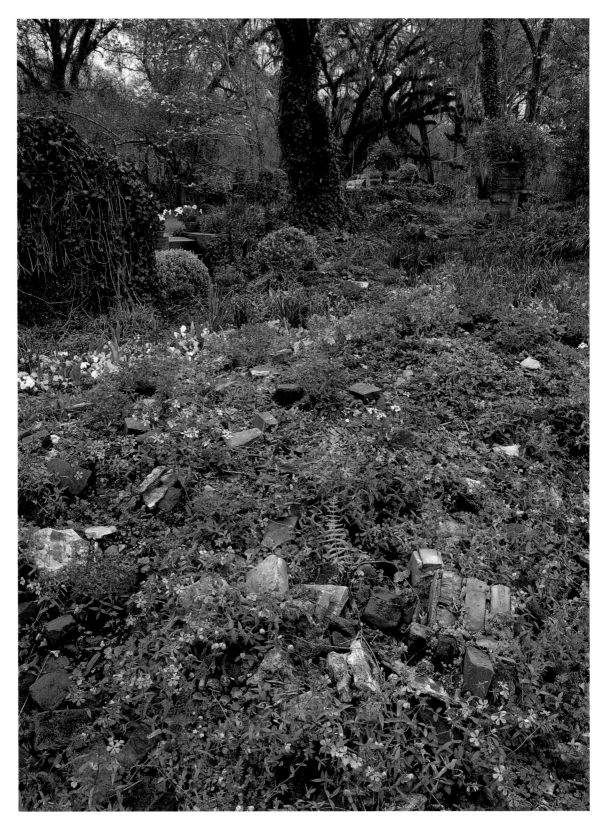

138. Afton Villa Gardens, St. Francisville, Louisiana, April. Fuji GX680, 65 mm lens at f/22, Fujichrome Velvia, Gitzo 320 Studex tripod. This charming cottage garden at Afton Villa combines plants and decaying architecture.

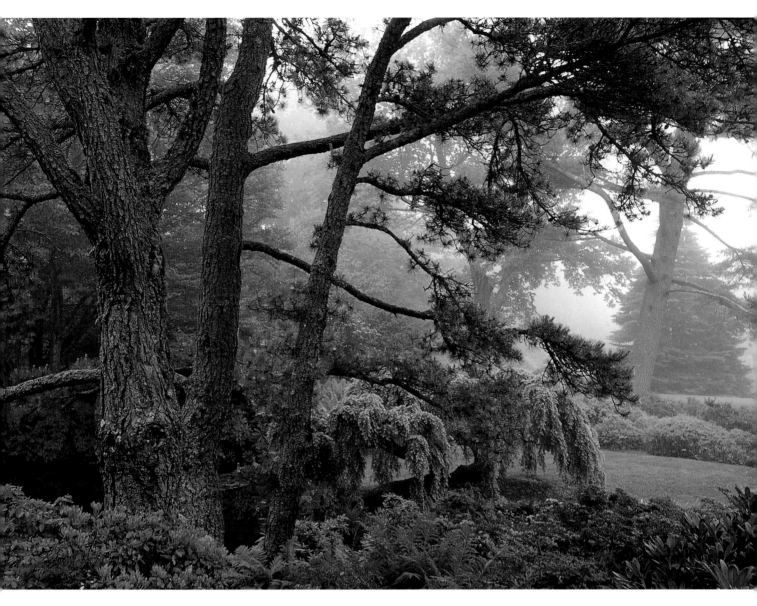

139. Pine trees in the mist, Asticou Azalea Garden, Northeast Harbor, Mount Desert Island, Maine, June. Nikon 8008s, 24–120 mm Zoom-Nikkor at f/16, Fujichrome Velvia, Gitzo 340G tripod. Asticou is a coastal New England garden established by Charles Savage in 1957 using many azaleas and other plants transplanted from an earlier Mount Desert Island garden owned by Beatrix Farrand. The 2.3-acre garden is at its showiest from mid May through June, when more than fifty varieties of azaleas and rhododendrons bloom.

140. Japanese maple abstract, Winterthur Garden, Winterthur, Delaware, April. Nikon F100, 70–180 mm Zoom-Nikkor at f/11, Fujichrome Velvia, Gitzo 340G tripod. I noticed this graphic pattern of branches and early spring foliage while visiting Winterthur, a magnificent woodland garden surrounding a splendid chateau built by Henry Francis (Harry) du Pont. Du Pont retained the natural features of the land and preserved as much of the existing vegetation as possible in his garden design.

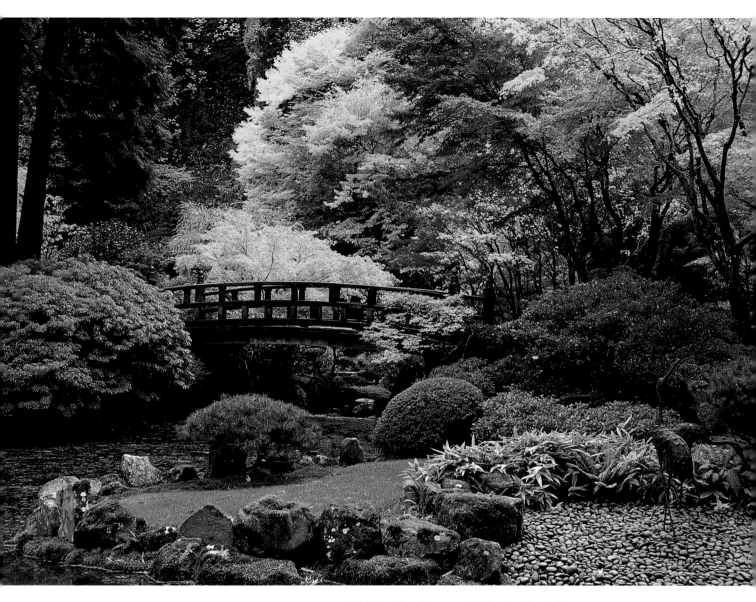

141. Fall color, Japanese Garden, Portland, Oregon, November. Nikon F100, 24–120 mm Nikkor lens at f/16, Fujichrome Velvia, Manfrotto 3444 tripod. Designed by Professor P. Takuma Tono in 1962, Portland's Japanese Garden was established on the original site of the city's municipal zoo in Washington Park.

142. Madrone bark, Elk Rock Garden at Bishop's Close,
Portland, Oregon, November. Nikon F100, 70–180 mm
Zoom-Nikkor, Fujichrome Velvia, Manfrotto 3444 tri-
pod. This estate garden is perched on a cliff south of
Portland, near Lake Oswego, overlooking the
Willamette River.

143. "Tree of Life" mosaic wall mural, Village of Arts and Humanities, Philadelphia, September. Nikon F100, 24–120 mm Zoom-Nikkor at f/11, Fujichrome Velvia, Gitzo 340G tripod. This is one of numerous murals in the urban gardens of south Philadelphia.

The Harris Poll consistently ranks gardening as one of America's most popular pastimes, and there are millions of beautiful, photogenic gardens in every corner of the country. Many Americans, however, guard their privacy fiercely, especially since September 11. Think twice before pointing your camera at a private garden without first obtaining permission.

To find excellent private gardens in your area, call your local chamber of commerce or library and ask for a list of local gardening clubs. Many of these organizations sponsor garden tours, usually in spring or summer, that are open to the public. The gardens are usually in tip-top condition, having been weeded, watered, pruned, and primped by their proud owners. You should encounter no problems taking along a camera on these garden tours, but ask permission before setting up a tripod.

The Gardeners of America/Men's Garden Clubs of America (TGOA/MGCA) is an excellent source for more information about garden clubs. This national organization encompasses 120 clubs in 28 states, with 7000 members, both male and female.

Experts estimate that as many as two-thirds of great American gardens have already been lost to the ravages of time. The Garden Conservancy was founded in 1989 to preserve exceptional American gardens for the public's education and enjoyment. Garden Conservancy members are eligible to receive an Open Days Directory, which lists gardens that may be visited. An individual membership is $35 per year.

144. Garden house and pond, Valerie Strong's garden, Hudson, Ohio, June. Fuji GX680, 65 mm lens at f/16, Fujichrome Velvia, Gitzo 340G tripod.
Valerie Strong's charming cottage garden is full of free-spirited perennials and annuals that assert their place around gravel walks and ponds.

145. Daylilies and delphiniums, Craig Bergmann's garden, Wilmette, Illinois, July. Fuji GX680, 100 mm lens at f/22, Fujichrome Velvia, Gitzo 340G tripod. Craig Bergmann designs sophisticated country gardens using a combination of design principles distilled from the best English estate and cottage gardens and a palette of more than two thousand herbaceous plants, including many unusual varieties.

THE BUSINESS OF GARDEN PHOTOGRAPHY

In 1990, after twenty years' work in management information systems and business consulting in England and corporate America, I decided to take the plunge into full-time freelance photography. During the first year, my income fell from a corporate salary of more than $75,000, plus paid vacations, health care, and other benefits, to a gross freelance income of less than $10,000, with no paid benefits. I sold my executive condominium and moved in with my parents, at age forty-four, to save money. It took four more years of hard work honing my photographic craft and marketing skills before I once again became self-supporting and was able to afford the small but comfortable home in northeastern Ohio where I now live. Although my photography has improved considerably with practice, I believe that my background as a business consultant has been a primary factor in the success I've enjoyed as a freelance photographer. In this chapter, I'll share some tips and guidelines for succeeding in the competitive world of garden photography.

MARKETS FOR GARDEN PHOTOGRAPHY

A visit to your local booksellers will reveal some of the many markets for garden photography. In the 1980s there were only a handful of garden magazines. Today there are dozens—all filled with beautiful photography. Among my favorites are *Horticulture, Fine Gardening, Midwest Living*, and *Country Living Gardener* (see also "Resources"). Most of these magazines rely heavily on freelance photographers to supply the color photography used in their editorial pages.

While you're visiting your bookseller, check out the gardening book section. Most large stores display hundreds of gardening books. Gardening is an intensely visual activity, and virtually all related books include scores, even hundreds, of color photographs, most of them obtained as stock photographs or through garden photography assignments.

The annually updated *Photographer's Market: 2000 Places to Sell Your Photography* (for example, Poehner 2003) is an excellent publication that will help you find buyers for your garden photography.

Although the editorial market, mainly magazines and books, comprises the majority of the market for garden photography, there are many other uses for fine garden photographs. Nurseries and other horticultural businesses need good photographs for advertisements. Calendars and posters often feature flowers and garden scenes, and colorful prints of garden vistas are very saleable. Garden clubs and other horticultural organizations are always searching for good speakers, and established garden photographers can present seminars and workshops in garden photography.

Never send an unsolicited submission of your photographs to a book or magazine editor. Photo editors are very busy people who are under no obligation to review or return unsolicited material, and your precious photos may be dumped unopened into the nearest trash bin!

If you want to approach a garden magazine, first review several back issues to make sure that your garden photographs are similar in scope and quality to those used by the magazine. Then write a one-page query letter, describing your garden photography and requesting a copy of the magazine's guidelines for photographers and writers. Be sure to include a self-addressed stamped envelope. Since garden magazines have access to tens of thousands of garden photographs, try to include one or more story ideas in your query letter to gain the editor's interest. The masthead, usually found within the first few pages of a magazine, lists the editorial staff and the address to be used for letters and other submissions.

STORING, ORGANIZING, AND SUBMITTING GARDEN PHOTOGRAPHS

As your collection of garden photographs expands, you'll need to spend some time developing a system to organize and store your images. I recommend storing your 35 mm color slides and larger color transparencies in clear archival storage pages. I purchase the following storage media from Light Impressions:

TransView sleeves, which store individual 35 mm slides

SlideGuard pages, which store twenty 35 mm slides per page, in slide mounts or TransView sleeves

PrintFile pages no. 45-4B, which store four 6 × 7 cm or 6 × 8 cm slides in black 4 × 5 inch frames

PrintFile pages no. 120-4UB, which store three strips of two unmounted 6 × 7 cm or 6 × 8 cm film

I obtain the black Pro-Dia 4050 4 × 5 inch frames for my 6 × 8 cm color transparencies from Think, Inc.

My multiple SlideGuard and PrintFile pages, organized geographically and by subject, are stored in hanging letter-size files in four-drawer vertical filing

cabinets made by Global. I currently have ten cabinets, containing more than fifty thousand color transparencies, and usually purchase one new cabinet each year.

I photograph gardens and other outdoor subjects throughout North America, and each state gets its own hanging file. Favorite states that I frequently visit have multiple hanging files, and Ohio, my home state, has its own filing cabinet, subdivided by county. Each book project gets a file cabinet drawer, with separate hanging files for each chapter. Similarly, each major public or private garden I have photographed, either for stock or on assignment, receives its own file. Stock subjects, such as trees, shrubs, and flowers, are filed alphabetically by Latin name.

Although many photographers use elaborate alphanumeric coding systems to identify their photographs, I haven't found this to be necessary so far. Nor have I taken the time to set up a searchable computer database of my photographs, based on keywords assigned to each photograph. The primary reason for not computerizing my garden photography collection is that stock photography is not a primary part of my business, most of my time being devoted to book projects, garden and other editorial photography assignments for clients, print sales, and photography workshops and slide programs. The non-garden subjects that I photograph extensively, including barns, historic bridges, lighthouses, harbor scenes, scenes of rural America, and architecture, are cross-filed by location and subject, and although I can't remember what I wore yesterday or ate the day before, I seem to be able to find my way around my photography files with speed and precision.

I suggest that you use a computer-based labeling program to label your color transparencies for client submissions or other projects. Handwritten slide labels, in addition to being sometimes misread, immediately brand you as an amateur and may cause your submission to be ignored by photo editors. I use Ellenco's ProSlide II labeling program, available for about $140 (Windows only). This program, with an available Image Workshop component (approximately $70), allows you to organize your photographs into searchable databases with thumbnail images that may be displayed and searched using keywords. Ellenco also markets some excellent wraparound 35 mm slide labels, in sheets of twenty suitable for laser or inkjet printers. For larger formats, I use Avery labels of various sizes, obtainable from any office supply store.

If you are invited by a garden magazine editor to submit photographs for review, package your slides carefully between two pieces of cardboard held together by rubber bands or easy-to-remove tape. Make sure you include your cover letter and a delivery memorandum, which lists the photographs you are enclosing together with your business terms and conditions of use for the photographs. Put the package in a reusable mailing carton (Uline is an excellent source for mailing materials). I use Federal Express for all of my submissions, but UPS and the U.S. Postal Service are also generally very reliable. Don't overwrap your submission with extra layers so that the photo editor has to spend lots of time opening it.

Allow at least six to eight weeks before contacting the magazine about your submission. Be patient: editors review dozens of photo submissions every week, and it may take a month or two before they get to yours. Avoid pestering photo editors with frequent phone calls.

Most publishers have standard pricing rates for the purchase of stock photographs. These rates are usually included in the publisher's photography guidelines and are generally nonnegotiable. Many other buyers of garden photography may not have published photography usage rates, however, and you will need to negotiate a fair price with these organizations for the use of your garden photographs. Stock photography pricing rates are based on the type of usage, the duration of usage, and the size of the photographs used with respect to the printed page.

Negotiating Stock Photo Prices (Pickerell and DiFrank 2001) is an indispensable publication that explores the process of valuing your stock photographs. In addition to its many pages of valuable information on the stock photography market, this publication includes pricing schedules, updated every few years, on virtually every type of usage for stock photography. A current copy of this book should be part of your reference library.

The American Society of Media Photographers (ASMP) is a valuable organization for aspiring freelance garden photographers. Founded in 1944 by some of the world's most prestigious photojournalists, ASMP is the leading professional organization devoted to serving the needs of photographers who photograph primarily for publication. More than forty North American chapters organize activities for ASMP's five thousand members, and a variety of excellent ASMP publications are available to members. You may also be able to find some of these publications for sale at booksellers in the photography section.

Finally, I strongly encourage you to join the Garden Writers Association (GWA), a group of more than eighteen hundred writers, photographers, and other communicators in the garden industry. GWA publishes a bimonthly newsletter, *Quill and Trowel*, and hosts a four-day annual symposium for members, where you can network with scores of fellow garden enthusiasts.

BUILDING BODIES OF WORK

About a decade ago, as I traveled around Ohio in search of scenic nature photographs for BrownTrout's *Wild and Scenic Ohio* calendar, I began to photograph Ohio's many public gardens, including Stan Hywet Hall and Gardens in my hometown of Akron. This magnificent Tudor Revival mansion, surrounded by seventy-five acres, was built in 1915 for rubber baron F. A. Seiberling. Several photos of its gardens appeared in BrownTrout's *Ohio Places* calendar, which I began in 1993, and in my first Ohio book, *The Ohio Lands* (1995). In 1998 I was commissioned by Stan Hywet Hall to photograph the gardens for an exhibit-format book, *Stan Hywet Hall and Gardens* (2000), which was later used as a model for *The Holden Arboretum* (2002). Based on the success of the Holden and Stan Hywet books, the Cleveland Botanical Garden commissioned me to produce photographs for another exhibit-format book, this one designed to celebrate the garden's seventy-fifth anniversary in 2005. I have undertaken other photography assignments for Stan Hywet Hall and Gardens, the Holden Arboretum, and the Cleveland Botanical Garden, and photographs of each garden are included in *Ohio: A Bicentennial Portrait*

MAKING COLOR PRINTS

Over the years your collection of color slides and digital images of gardens, plant close-ups, and other horticultural subjects will expand to become your personal library. From time to time you may wish to produce color prints from these photographs for clients, family, or friends. Powerful and affordable personal computers, scanners, and printers, coupled with a broad range of new digital printing technologies available from service bureaus and color labs, have created a wealth of options for producing superb color prints from your garden photographs.

When reviewing color print options, consider print quality, print longevity, and cost. Print quality includes sharpness, grain, and color saturation and accuracy. Print longevity, which is a measure of how long a color print will last without noticeable fading, can vary from one to two years for some color prints to a hundred years or more for pigment color inkjet prints. The cost of producing a color print can range from a few dollars for an 8 × 10 inch inkjet print produced on a home personal computer to hundreds of dollars for a 30 × 40 inch digital Ilfochrome or Fuji Crystal color print produced at a commercial color lab.

Until recently the only way you could produce color prints from slides at home was to set up a color darkroom with a color enlarger, print processor, and chemicals. This kind of color printing is challenging, time-consuming, and often frustrating, with costs that can easily exceed several thousand dollars. Luckily, the availability of powerful, low-cost personal computers, scanners, and inkjet printers offers an attractive alternative: the digital darkroom.

SETTING UP A DIGITAL DARKROOM

To make color prints from your slides or negatives, you'll need a personal computer, a scanner (if your photos are slides or negatives), an image editor,

and a color inkjet printer. You'll also need a supply of CDs or DVDs to store the digital files you'll create to make your prints.

Personal Computers

Today's desktop and laptop personal computers (PC or Mac), equipped with powerful 2 GHz (gigahertz) or 3 GHz processors, are more than adequate for processing and printing your garden photos. Since digital image files can be quite large, make sure you have at least 256 MB, and preferably 512 MB or more, of RAM (Random Access Memory). RAM is becoming more and more affordable, and the more RAM you have the faster your images will be processed. Get as much RAM as you can afford.

Virtually all personal computers include a drive that can read files from a CD or DVD and store files by burning them onto a CD or DVD, using a software package such as Roxio's Easy CD Creator. You can store dozens of small digital image files, or several larger ones, on a single CD or DVD, making this an efficient and economical way to store your favorite garden images.

Another important consideration is the PC color monitor you use to view your garden images prior to printing them. Although laptop LCD screens have improved markedly, they still aren't a substitute for a high-quality CRT (Cathode Ray Tube) monitor. Since you'll probably spend far more time in front of your PC screen than behind your camera viewfinder, a good monitor is an excellent investment. A 17-inch monitor is the absolute minimum size for comfortable viewing, and a 19-inch or 20-inch CRT monitor, which can be purchased for about $200, is an even better choice. I use a 22-inch ViewSonic P225f monitor, which provides plenty of room for displaying multiple images and has a large, bright, sharp display that is a pleasure to use for extended PC sessions, which may last for several hours.

Finally, if you live in an area that is subject to frequent power interruptions or fluctuations, make sure you invest in an uninterruptible power supply (UPS).

Scanners

If your originals are color transparencies or color or black-and-white negatives, you will need to invest in a scanner. Recent innovations in scanner design and technology have resulted in a new generation of powerful, cost-effective flatbed and dedicated film scanners.

A flatbed desktop scanner that can scan film or printed originals up to at least 8.5 × 11 inches is an excellent addition to any home office. Popular brands include Canon, Epson, Hewlett-Packard, and Microtek. Most models include a transparency adaptor, usually in the hinged lid of the scanner, which allows you to scan mounted 35 mm color slides, unmounted 35 mm and 120 mm film in strips, and even 4 × 5 inch color transparencies.

My personal recommendation is Epson's versatile Perfection 4870 flatbed scanner, which produces excellent scans of film up to 4 × 5 inches at an optical resolution of 4800 ppi. I use this scanner to scan 4 × 5 inch color transparencies and to make general-purpose color copies. The quality of the scans is excellent, and at a cost of around $375, this scanner is very affordable.

Although inexpensive flatbed scanners like the Epson Perfection 4870 are excellent general-purpose scanners, for the highest-quality scans of 35 mm and 120 mm film originals, nothing beats a dedicated film scanner. Popular brands include Canon, Imacon, Konica Minolta, and Nikon. The latest gen-

eration of desktop film scanners offer scanning resolutions of 4000 ppi or more and produce scans that rival the quality of those obtained from commercial drum scanners costing tens of thousands of dollars.

I use a Konica Minolta DiMAGE Scan Elite 5400 to scan my 35 mm color slides at 5400 ppi, producing a 16-bit 200 MB file that allows me to make superb 20 × 30 inch color prints at 240 ppi. This scanner is fast, with an excellent autofocus system, very accurate color reproduction, and Digital ICE for the suppression of dust and scratches. I've had equally good results from the DiMAGE Scan Multi Pro, which allows me to scan my 6 × 8 cm color transparencies at 3200 ppi and my 35 mm color slides at 4800 ppi. In all other respects it is essentially identical to the DiMAGE Scan Elite 5400, and in fact uses the same software. I can easily produce 40 × 50 inch prints at 180 ppi from my 6 × 8 cm color transparencies using this superb scanner.

I have also had good results with the Nikon Super Coolscan 8000 ED, which scans medium-format film at 4000 ppi, and the Nikon Super Coolscan 4000 ED, which scans 35 mm film at 4000 ppi. These scanners were replaced in late 2003 with the Nikon Super Coolscan 9000 ED and 5000 ED, which offer faster scanning speeds and other improvements. I haven't tested them, but detailed reviews may be found on several Web sites.

Reconditioned older-model scanners from Nikon and other scanner manufacturers are also available for well under $1000.

I recommend that you scan each 35 mm slide or negative at the highest resolution possible (for example, 4000 ppi) to extract the maximum amount of detail. For larger transparencies, scan at an output resolution of 300 ppi at the largest size you plan to print the image. This means that you will need to scan each original photograph only once.

Image Editors

When you have scanned your film to produce a digital image, the next step is to adjust and refine the image prior to making a print. These adjustments are made using a software package called an image editor. The industry standard image editor is Adobe Photoshop. There are other image editors available, including Picture Publisher and Corel Photo-Paint, but Photoshop is the clear choice of most professionals, and I suggest you consider purchasing it. The current version, Photoshop CS, costs about $700. If you would prefer to try a scaled-down version of Photoshop before investing in the full package, Adobe offers an entry-level version of Photoshop called Photoshop Elements, often included with purchases of scanners, digital cameras, and inkjet printers, or available for purchase at less than $100.

Using Photoshop, the basic process of adjusting a scanned image prior to printing is as follows:

1. Use the Crop tool to adjust the framing of your photo to your liking.

2. Adjust the brightness and contrast of the image using the Levels command and Curves command, both found under the Adjust option on the Image menu.

3. Adjust the color and color intensity of the image using the Color Balance command and Hue/Saturation command, also found under the Adjust option on the Image menu.

4. Remove any scratches and dust spots using the Clone Stamp tool.

5. Under the File menu, select *Save* to save the image as a master RGB file.

6. Use the Image Size command, under the Adjust option on the Image menu, to resample the master file to create a file the size of the print you want to produce.

7. Sharpen the image using the Unsharp Mask filter, found under the Sharpen option on the Filter menu.

8. From the File menu, select *Print*.

Adobe and other organizations offer a variety of tutorials, seminars, and workshops designed to help you learn how to use Photoshop. Adobe also offers the *Classroom in a Book* series, excellent hands-on tutorials that you can use at your own pace on your own personal computer. Finally, there are dozens of books available on Photoshop from your local bookseller. One of my favorites is *Photoshop CS Artistry: Mastering the Digital Image* by Barry Haynes and Wendy Crumpler (2004). Barry is an accomplished nature photographer as well as a nationally recognized expert on Photoshop and digital printmaking, and the photographs used as examples and tutorials in his book are especially relevant for nature and garden photographers.

Color Inkjet Printers

Since about 2000, a technological revolution has taken place in the world of color inkjet printers for home or small business use. Although several companies, including Hewlett-Packard and Canon, have been active participants in this arena, Epson is leading the field, pioneering the introduction of high-quality, inexpensive color inkjet printers that can produce color prints which rival, or even surpass, the quality and longevity of those made using traditional printmaking methods at commercial color labs and service bureaus.

For about $60, you can purchase an Epson dye color inkjet printer that will produce excellent 8.5 × 11 inch prints, such as the C64. The Epson Stylus Pro 1280 printer, priced at about $375, will allow you to produce outstanding color prints up to 13 inches wide, on either sheet or roll paper. A 12 × 18 inch print produced on 13 × 19 inch paper is a nice-sized print from a 35 mm color slide, and it costs only a few dollars for ink and paper. The 1280 uses dye-based inks and can print on a variety of glossy, matte, or special papers, including canvas and watercolor papers.

The Epson Stylus Pro 2200, which costs about $650, uses a seven-color, pigment-based system to produce superb-quality color prints, up to 13 inches wide, that when used with recommended Epson papers will last without noticeable fading for more than a hundred years. For larger prints, Epson has introduced the 24-inch Stylus Pro 7600 and the 44-inch Stylus Pro 9600. Since purchasing a Stylus Pro 9600, I have used it to make all my color prints from 8 × 10 inches to 44 × 50 inches, at a fraction of the cost of commercially produced Ilfochrome and C-prints, with improved quality.

RESOURCES

This is by no means a comprehensive list of resources. Rather, I have tried to select the best from among the multitudes of magazines, organizations, Web sites, and equipment manufacturers vying for your attention. When in doubt, you can always check an Internet search engine such as Google, which should produce a blizzard of Web pages for your viewing pleasure.

GARDENING MAGAZINES

Better Homes and Gardens. www.bhg.com
Country Living Gardener. www.clgardener.com
Fine Gardening. www.taunton.com/
 finegardening
Garden Design. www.gardendesignmag.com
Horticulture. www.hortmag.com
Midwest Living. www.midwestliving.com

ORGANIZATIONS

American Association of Botanical Gardens and Arboreta (AABGA)
100 West Tenth Street, Suite 614
Wilmington, Delaware 19801
phone: 302-655-7100
fax: 302-655-8100
www.aabga.org

American Society of Media Photographers (ASMP)
150 North Second Street
Philadelphia, Pennsylvania 19106
phone: 215-451-2767
fax: 215-451-0880
www.asmp.org

Garden Conservancy
P.O. Box 219
Cold Spring, New York 10516
phone: 845-265-2029
fax: 845-265-9620
www.gardenconservancy.org

Garden Writers Association (GWA)
10210 Leatherleaf Court
Manassas, Virginia 20111
phone: 703-257-1032
fax: 703-257-0213
www.gwaa.org

The Gardeners of America/Men's Garden Clubs of America (TGOA/MGCA)
P.O. Box 241
Johnston, Iowa 50131
phone: 515-278-0295
fax: 515-278-6245
www.tgoa-mgca.org

WEB SITES

Digital Imaging. www.imaging-info.com/
digitalimagingmag
A useful magazine with technical information provided by digital experts.

Digital Photography Review. www.dpreview.com
Digital camera reviews and discussion forums.

Ian Adams Photography.
www.ianadamsphotography.com
My own Web site.

Imaging Resource. www.imaging-resource.com
Another excellent Web site for digital equipment
reviews.

Luminous Landscape.
www.luminous-landscape.com
An excellent source for reviews and stimulating
articles on outdoor photography.

PC Photo. www.pcphotomag.com
An excellent magazine for digital photography
beginners.

Photoshop User. www.photoshopuser.com
Published by the National Association of
Photoshop Professionals, this is an excellent
resource for serious Photoshop users.

Rob Galbraith. www.robgalbraith.com
Digital photography news, reviews, tutorials, and
discussion forums.

Thom Hogan. www.bythom.com
Thom Hogan's extensive articles, reviews, and
books on Nikon equipment.

EQUIPMENT AND SUPPLIES

Adobe
toll-free phone: 800-833-6687
www.adobe.com
Print and Web publishing products such as
Photoshop and GoLive.

Anne Laird Photo Accessories
P.O. Box 1250
Red Lodge, Montana 59068
phone: 406-446-2168
www.apogeephoto.com/laird_photo.htm
Tripod leg covers.

B&H Photo
420 Ninth Avenue
New York, New York 10001
toll-free phone: 800-221-5743
toll-free fax: 800-947-7008
www.bhphotovideo.com
Photographic equipment, film and digital.

Bogen Imaging
565 East Crescent Avenue
P.O. Box 506
Ramsey, New Jersey 07446
phone: 201-818-9500 and 212-695-8166
fax: 201-818-9177
www.bogenimaging.us
Manfrotto and Gitzo tripods.

Canon
www.canon.com
35 mm cameras, lenses, scanners, and other
equipment for both film and digital photography.

Ellenco
P.O. Box 159
Tijeras, New Mexico 87059
phone/fax: 505-281-8605
www.proslide.net
Proslide software for labeling slides.

Epson
toll-free phone: 800-922-8911
www.epson.com
State-of-the-art dye and pigment color inkjet
printers.

Filmtools
3100 West Magnolia Boulevard
Burbank, California 91505
phone: 818-845-8066
toll-free phone: 888-807-1900
www.filmtools.com
Gray cards.

Hoodman Corporation
20445 Gramercy Place, Suite 201
Torrance, California 90501
phone: 310-222-8608
toll-free phone: 800-818-3946
www.hoodmanusa.com
Monitor hoods.

Inkjet Art Solutions
346 South 500 East, Suite 200
Salt Lake City, Utah 84102
phone: 801-363-9700
fax: 801-363-9707
www.inkjetart.com
Inkjet inks, papers, and information on inkjet printing in both color and black-and-white.

Kirk Enterprises
phone: 260-665-3670
toll-free phone: 800-626-5074
www.kirkphoto.com
Tripods, tripod heads, and mounting plates.

Leonard Rue Enterprises
138 Millbrook Road
Blairstown, New Jersey 07825
phone: 908-362-6616
www.rue.com
Photographer's gloves.

Light Impressions
P.O. Box 787
Brea, California 92822
toll-free phone: 800-828-6216
toll-free fax: 800-828-5539
www.lightimpressionsdirect.com
Archival storage media for film and prints.

Lowepro
P.O. Box 6189
Santa Rosa, California 95406
phone: 707-575-4363
www.lowepro.com
Camera bags.

Monaco Systems
100 Burtt Road
Andover, Massachusetts 01810
phone: 978-749-9944
fax: 978-749-9977
www.monacosys.com
ICC-profiling solutions.

Nikon
www.nikonusa.com
35 mm cameras, lenses, scanners, and other equipment for both film and digital photography.

Really Right Stuff
P.O. Box 6531
Los Osos, California 93412
phone: 805-528-6321
toll-free phone: 888-777-5557
fax: 805-528-7964
www.reallyrightstuff.com
Tripods, tripod heads, and mounting plates.

Ruxxac
www.ruxxac.com
Pull carts.

StoreYourMedia.com
2700 Mission College Boulevard, Suite 140-W
Santa Clara, California 95054
toll-free phone/fax: 866-786-7323
www.storeyourmedia.com
Storage products.

Tamrac
9240 Jordan Avenue
Chatsworth, California 91311
phone: 818-407-9500
toll-free phone: 800-662-0717
fax: 818-407-9501
www.tamrac.com
Modular camera bags and cases.

Think, Inc.
4924 Buttermilk Hollow Road
West Mifflin, Pennsylvania 15122
phone: 412-469-2210
www.think-inc.net
Pro-Dia transparency mounts.

Uline
2105 South Lakeside Drive
Waukegan, Illinois 60085
toll-free phone: 800-958-5463
toll-free fax: 800-295-5571
www.uline.com
Mailing materials.

Wimberley
974 Baker Lane
Winchester, Virginia 22603
phone: 540-665-2744
toll-free phone: 888-665-2746
fax: 540-665-2756
www.tripodhead.com
Tripod heads, mounting plates, and clamps.

ABOUT THE AUTHOR

Ian Adams is an environmental photographer, writer, and teacher based in Cuyahoga Falls, Ohio, specializing in natural, rural, historical, and garden photography. More than three thousand of his color photographs have appeared in hundreds of publications, including books, calendars, and magazines, and he has coauthored six books of photography on regional subjects. In addition to his freelance work, Ian conducts garden photography workshops and seminars.

Photo by Bridget Commisso.